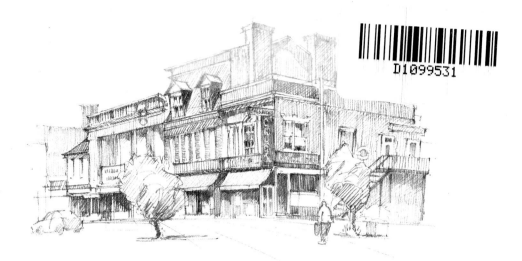

Draw and Sketch
Buildings
16 Projects in 6 steps or less

Jim Woods

C275782

SEARCH PRESS

A QUARTO BOOK

Published in 2002 by Search Press Ltd.
Wellwood
North Farm Road
Tunbridge Wells
Kent
TN2 3DR

ISBN 1-903975-16-6

QUAR.LDB

Conceived, designed, and produced by
Quarto Publishing plc
The Old Brewery
6 Blundell Street
London N7 9BH

Senior Project Editor: Nicolette Linton
Senior Art Editor: Penny Cobb
Designer: Brian Flynn
Photographers: Colin Bowling,
 Paul Forrester
Copy editor: Hazel Harrison
Proofreader: Kate Phelps
Indexer: Pamela Ellis

Art director: Moira Clinch
Publisher: Piers Spence

Manufactured by
Universal Graphics Pte Ltd., Singapore
Printed by
Star Standard Industries Pte Ltd.,
Singapore

Contents

Introduction

People are often heard to say, "I wish I could draw, but I can't manage a straight line". Although in some exceptional cases artistic skill or talent is a gift – artists such as Picasso were drawing with confidence and fluency from an early age – drawing skills can be learned by anyone who truly wants to acquire them. It is never too late to start; all you need is the will, the enthusiasm and the recognition that you may make mistakes and will need to practise. If your first efforts are disappointing, don't despair. If nothing else, they will have taught you to look at shapes and colours with a new eye, and to appreciate the buildings themselves, which form the subject of this book. And when a drawing or a painting, however modest, really does work, it's a pleasure beyond belief.

Personally, although I was reasonably good at drawing at school and attended art

college for a short period after school, I didn't do any serious drawing or painting for the next forty-five years until I retired. I consider myself not only self-taught, but also a fairly late starter; it's never too late to start if you really want to.

Some people may find the subject matter of this book daunting, especially those who claim not to be able to draw straight lines or cope with perspective. But straight lines can be drawn with a ruler, and the laws of perspective are very easily learned. Once you are over the initial hurdles, buildings make a wonderful subject with almost endless possibilities, whether you are sketching from afar or inspired by close-up architectural detail.

Most of us are surrounded by buildings – few people live very far from some sort of structure – so just look around you and you will see potential subjects. Before you start, glance through the pages of this book, which I hope will provide some help and inspiration.

Jim Woods

Materials for projects

Below is a list of the materials you will need for each project. Use good-quality drawing paper unless otherwise stated.

Note that coloured pencils and pastels, in particular, are available in a vast range of colours and the names vary considerably from one manufacturer to another. For this reason, pastels and pencils are listed as generic colours (blue, green, for example) rather than as specific manufacturer's shades. Choose the colours from your preferred range that seem to match the ones in the projects most closely.

The size of the brush you use will depend on your own personal taste and on the scale of the drawing you're producing. Brush sizes are therefore given as 'small' or 'medium', to give you a general guideline about what to select.

But don't worry if you don't have exactly the right equipment to hand: these projects are merely a stepping stone to help you develop your own ways of interpreting buildings and, as always in art, keen observation is the key to success.

HARBOUR SKYLINE • Ballpoint pen

SMALL-TOWN DRUGSTORE • 3B pencil • Paper towel

RUSTIC HILL TOWN • Sanguine conté pencil

MOSQUE ROOFS • Watercolour paper • 2B pencil • Large flat brush • Water-soluble sepia ink • Water-soluble black ink • Fine-nibbed art pen • Medium-nibbed art pen

RAINBOW APARTMENTS • Felt-tip pens: pale grey, green, yellow, red, blue, purple in various tones

ONION SPIRES • Watercolour paper • 2B pencil • Watercolour paints: Winsor red, raw sienna, yellow ochre, chromium oxide green • Small round brush • Medium-sized round brush

CITYSCAPE • Watercolour paper • 2B pencil • Pastel pencils in various tones: indigo, dark blue-grey, ultramarine blue, yellow, ochre, bluish green, red-brown, mauve, white

THE PINK HOUSE • Watercolour paper • Carbon pencil • 3B or 4B graphite pencil • Watercolour paints: raw sienna, alizarin crimson, sepia, burnt umber, ultramarine blue, Payne's grey, indigo • Small round brush • Medium-sized round brush • Tissue • Fine-nibbed art pen • Water-soluble black ink

ROOFTOPS • B pencil • 7B pencil

STREET SCENE • Watercolour paper • 3B graphite pencil • B graphite pencil • 2B carbon pencil • Watercolour paints: raw sienna, cadmium orange, light red, yellow ochre, indigo, Payne's Grey, ultramarine blue, raw umber, burnt sienna, burnt umber, cadmium red, cadmium yellow • Flat brush

COLONIAL MANSION • Watercolour paper • HB pencil • H pencil • Watercolour paints: Prussian blue, burnt umber • Small round brush • Medium-sized round brush • Drawing pen • Black ink • Candle • Lino-printing roller

LEANING TOWER • HB pencil • 2B pencil • 4B pencil

STREET SIGNS • 2B pencil • Coloured pencils: light green, red, yellow, orange, brown, greenish grey, yellow, green, dark red, blue, black, dark violet, grey-mauve • Plastic eraser • Scalpel

SOUTHERN GRANDEUR • Watercolour paper • HB pencil • Fine-tipped drawing pen • Water-soluble black ink • Medium-sized round brush

DERELICT KIOSK • Watercolour paper • 3B pencil • Watercolour paints: raw sienna, indigo, viridian, burnt sienna, ultramarine blue, cadmium red • White gouache • Small round brush • Medium-sized round brush

REFLECTIONS IN A CANAL • Watercolour paper • Carbon pencil • Watercolour paints: ultramarine blue, raw sienna, sepia, alizarin brown madder, viridian • Fine-nibbed art pen • Black water-soluble ink • Small round brush

Getting started

You will need to start by investing in some basic equipment if you don't already have it. If you are new to sketching, don't be seduced by the more exotic and expensive mediums. Stick to pencils and paper for your first attempts.

What you will need

Graphite pencils come in a wide range from very hard (6H) to very soft (6 or even 8B), but initially an HB, a 2B and a 4B will be adequate. You will need drawing (cartridge) paper, which can be bought either in sketchbooks, pads or in large sheets that you can cut to size and use on a drawing board. You don't really need much else, except for a soft eraser, but two useful extras are, first, a ruler – many of us are unable to draw straight lines, and why invite early frustration? – and second, a viewfinder, which you can make yourself simply by cutting a rectangular hole in a piece of cardboard.

Basic kit *Include three grades of pencil, an eraser, a ruler and a sketchbook or sketchpad in your kit.*

Create a viewfinder
Experiment with a viewfinder to find the most interesting scene to sketch. Your first viewpoint may not be the most interesting. Try a portrait and a landscape format and see the difference it makes to the composition.

Looking at the subject

Once you have selected your subject, the next step is to decide how to place it on the paper. Will it fit best into an upright or horizontal shape (more about this under *Composition* on pages 66 to 67)? Do you want to include an area of foreground? Do you want to draw the whole building or only part of it?

When you have made these decisions, the next, and vitally important, step is deciding where to start your drawing. The natural inclination is to start from the top, but this is likely to get you into trouble, as you will almost certainly have run out of paper before you reach the bottom. Instead, make light marks where you think the extremities of your subject will fall and then make further marks to indicate various keypoints in the subject. These

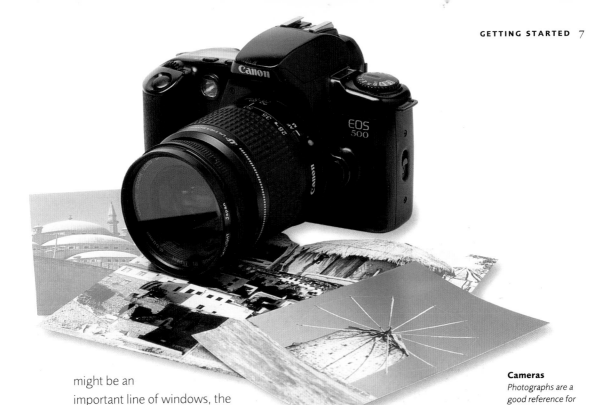

Cameras
*Photographs are a
good reference for
finishing a sketch at
home. Take pictures
of the view at
different angles
and with changing
light effects.*

might be an
important line of windows, the
top of a door or a central balcony.

If you are working on a sunny day and
shadows are important, make a note of the direction of the light just – put a
small cross on the relevant corner of the paper – as the pattern of light and
dark will change as the day progresses.

Starting to draw

Once you have plotted your drawing, dive in and be as bold as you can,
drawing lines with confidence rather than feeling your way with tentative little
marks. Accuracy will come with practice, but at this stage just concentrate on
enjoying making marks on paper. Vary the pressure on the pencil to create
light and dark lines, and experiment with different ways of building up areas of
tone, such as hatching and crosshatching or smudging the pencil with your
finger. The pencil is a very versatile drawing tool and can achieve a wide
variety of effects.

The role of the camera

Many artists take their cameras with them when sketching outside in case the
weather changes or they can't finish in time. It is wise to follow their example;
few people now regard the use of photographs as cheating. Pictures provide
a useful back-up to a half-finished sketch. And, of course, there are some
subjects that you can't draw on the spot; there may be nowhere to sit, or
you may just be passing through a place on holiday and not have time to stop.
On the following pages, you will find advice on how to make an accurate
drawing from a photograph.

The Fundamentals

This section of the book outlines the basic principles and techniques that are fundamental to drawing and sketching. The section is divided into subject areas such as Drawing with Colour or Perspective, and the information is conveyed through simple step-by-step exercises.

THE FUNDAMENTALS

Simple shapes and forms

Although architectural subjects can seem daunting at first, they are a good deal less complex than many others. Mainly, you will be dealing with simple geometric shapes, mostly rectangles of varying sizes and proportions – the building itself, the doors and the windows – together with triangles, which may form the roof structures. Occasionally you will come across a circle or semi-circle. For example, some buildings have round windows or a fanlight above a door. Look for these shapes and see how they relate to each other.

How to draw what you see

Initially, the most important aspect of drawing buildings is getting the proportions right. Look for the main shape first, and ask yourself whether it is more or less square, or forms a tall rectangle with a height considerably greater than its width. You can then check the exact proportions by measuring them. Measure the width by holding your pencil at arm's length and sliding your thumb along it. Then turn the pencil upright and see how many of these measurements fit into the vertical. You can check the proportions of windows and doors in the same way – and don't forget the spaces between them, which are just as important.

Measuring angles
To make sure that your building looks three-dimensional, hold a pencil at arm's length and angle it until it coincides with the line you wish to draw. Take the pencil carefully down to the paper at the same angle and draw the line.

How viewpoint affects shapes

The perceived shape of a building is affected by the angle of viewing, because here perspective comes into the equation. If you look at a building straight on you see just one rectangle (one plane) but if you view it from an angle you will see two, the front and the side, and the lines at the top will slope downwards, changing the basic rectangle into a more complex, and often much more exciting, geometric shape. To accurately represent the shape of these angles, use the pencil again, holding it up and angling it until it coincides with the top line, then taking it carefully down to the paper.

Work from a grid
A grid will help you plot your drawing. Decide on the size of your drawing and draw the same number of squares on your paper, in light pencil, as are on your viewing grid. You will then be able to transfer the information you see through the grid onto your paper.

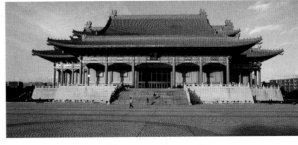

Double-checking shapes

Shapes are easier to spot if you can isolate them, cutting out the clutter that surrounds them. Holding up a viewfinder makes a frame for the subject so that you can relate the main shape to the edges of the 'frame'. And if you are lucky enough to have chosen a building set against nothing but sky, you can also check the shapes of the building by looking at the 'negative shapes' formed by the sky. These are often easier to spot than the 'positive shapes' of the building itself, where you tend to be distracted by detail.

Simplification
Negative shapes are often easier to detect than positive shapes, as the detail of the building can be distracting. The shape of a light building will show up better against a dark sky, as will a dark building against a light sky.

Making a grid

If you are working from a photograph, you may find it helpful to use a squaring-up method to make your drawing. Take a piece of cardstock roughly 12.5 x 18cm (5 x 7 '') in size and cut a hole in the centre to match the size of the photo or drawing. Fix a piece of fairly stiff transparent material over the back of it and rule this up into 1.5-cm ($^5/_8$-inch) squares with a permanent felt-tip pen. If you lay this over the photo and then rule larger squares on the paper – you can decide on the proportion you want – you can then accurately transfer the information from the photo to the paper.

This grid-type viewfinder is also useful for checking proportions and angles when working outdoors, though it is more or less impossible to draw through it, as you simply can't hold it in the same position for long enough.

EXERCISE I

Harbour skyline

by Jane Hughes

A monochrome treatment with strong tonal contrasts is ideal for this dramatic view in which the juxtaposition of simple shapes is the most powerful element. A ballpoint pen can produce more solid darks than a pencil, as well as a wide variety of different marks. The disadvantage is that it cannot be erased, which may make it seem rather intimidating, but the immediacy and freshness of first-time drawing makes for a lively result. Once you have mastered the technique of taking measurements, you should be able to place your marks quite accurately, and deciding how to frame the drawing will enable you to make an exciting composition. Here the artist has been selective, concentrating on the group of buildings to the left of the catamaran, which provide a dynamic mix of rectangular and curved shapes.

Practice points

- TAKING MEASUREMENTS
- FRAMING THE DRAWING
- WORKING IN MONOCHROME
- CREATING A PATTERN OF LIGHT AND SHADE

Plot the drawing outwards from the centre, measuring as you go. Don't forget the height; the tallest building is just a little bit shorter than half the length of the baseline.

Measure the middle of the baseline and mark a vertical centre line for the composition, drawing in the position of the right-hand side of the skyscraper just above the left-hand stack of the Opera House roofs.

Make a mark above this baseline at about two-thirds of its length and another mark at about one-third of its length below; these show you the top and bottom of the drawing, and can easily be hidden later.

STAGE I

THE FRAMEWORK

■ With practice, measuring becomes a natural part of the sketching process. Hold the pen out at arm's length to measure your subject and compare the measurements you make with the marks you draw. The composition is roughly square, with no formal frame so, to find your bearings on the page, lightly draw in the waterline as a baseline for the buildings. This line measures the width of the finished sketch, and from it you can plot all the points that will define your drawing and its edges.

STAGE 2
FINALISE THE PLOTTING

■ Take care not to overwork at this stage; you want to keep the drawing fresh. Indicate the position of each building lightly, starting with small dots and then joining them up with lines. Carefully work out the overall height and width of the Opera House and where it sits in relation to the other buildings. It needs to be accurately placed, as it is the only curved shape (apart from the sailboats, which you can think about later), as well as being the largest area of light tone in the composition.

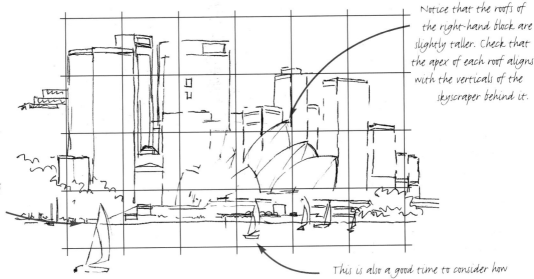

Notice that the roofs of the right-hand block are slightly taller. Check that the apex of each roof aligns with the verticals of the skyscraper behind it.

You can now introduce some of the less rigidly defined features of the scene, such as these trees, and the promenades just above the waterline.

This is also a good time to consider how to echo the shapes of the Opera House with some strategically placed sailboats. You don't want too many, so some can be edited out and a slightly larger one added in the left foreground.

STAGE 3
ADD PATTERN AND TONE

■ Now that the basic drawing is established, you can begin to address the pattern of light and shade. Try to keep it light at first; you can always add more to the drawing, but it's easy to overdo it. Notice the different arrangements of windows in the towers; in some cases the emphasis is horizontal, while others are more vertically striped, or form a chequerboard pattern.

Define each building with its own particular pattern. Notice how the light is falling from the left side, and the shadows cast by the buildings help to clarify their shapes.

Use light pen strokes to establish the pattern grids. The marks can be strengthened as necessary when the sketch is more developed.

Ballpoint pen is relatively clean to use, but it can smudge if the marks are touched before the ink has dried properly. It is wise to use a spare sheet of paper to protect it as you work.

STAGE 4
BUILD UP THE TONES

■ You can vary the tones by using more or less pressure and by making the hatching lines closer together. The hatching lines themselves can be varied to suit the subject, ranging from evenly spaced strokes to more random marks.

By working up this large, dark area of glass gradually from very light to very dark, you can grade the tones smoothly to show the planes of its walls.

Use a more scribbly line for the trees. They are not the main focal point of the sketch, but they play their part in the composition, as their loose shapes and uneven texture complement the hard, smooth shapes of the buildings.

Darken the window patterns on the shaded side of the buildings to give form and interest to the group. This window also provides a vertical counterfoil to the curves below.

Deep shadow in front of each curved roof throws its shape into heavy relief. These lines can be curved to follow the shapes.

Strengthen the shadow details for a little more contrast and break up the uniformity of the promenades with some light, scribbly texture.

STAGE 5
MORE TONE AND DETAIL

■ Now you can start to work on the water, building up a range of tones to balance those in the group of buildings. This foreground area also provides a contrast in kind, with a fluid, moving mass set against the solid and static buildings. It can be more loosely drawn, but take care not to lose the overall horizontality of the surface.

The water appears darker near the building line, because it is farther away and the ripples cannot be seen. In the foreground, the ripple effect is obvious, so the lines should be opened out. Vary the weight of marks as appropriate and allow the drawing to fade out at the lower edge.

Work around the boats, keeping the direction of the marks predominantly horizontal. Allow some points of light to break up the surface.

STAGE 6
FINAL ADJUSTMENTS

■ Although this is a drawing of a very solid subject, its strong shapes are balanced by a range of different weights and textures of marks. The angular buildings create dramatic tension against the water and sky, with the curved sails of the boats linking the main elements of the picture.

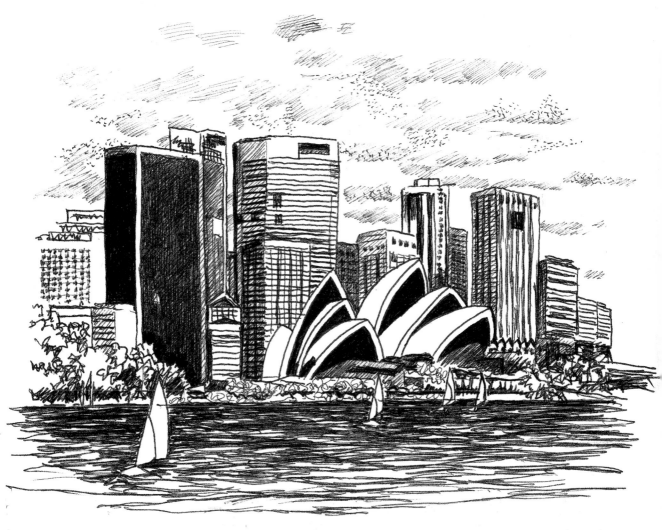

Make any final adjustments to the shadows on the skyscrapers and deepen the shade beneath the Opera House roofs to as near black as you can get.

You can now hide the top 'framing' mark by sketching in some clouds, using light diagonal cross-hatching. Notice their almost regular formation.

Use light stippled marks combined with very light hatching strokes to draw the shadows below the clouds and the sky between them.

THE FUNDAMENTALS

Tonal values

The word tone, or value, simply describes the lightness or darkness of a colour, running through a scale from white to black. Tonal values would be easy to identify if the world were seen in monochrome, but colour complicates the issue, because it registers so strongly. It is important to be able to assess value, as drawings or paintings with little or no tonal contrast look dull and bland (the exception, of course, being line drawings, which rely on the quality of line for their impact). To work out the tonal values in a subject, it is helpful to look at it through half-closed eyes, which cuts out some of the colour and detail.

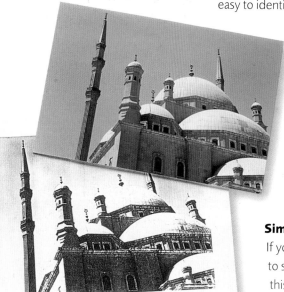

Discover tonal values *One way of finding out the tonal values in a colour photograph is to photocopy it in black and white.*

Simplifying tones

If you are drawing in monochrome, you will have to simplify the tones, and the best way of doing this is to try to visualise a range from white to pure black with three greys in between. If you are sketching or drawing in colour, you can use a greater range of values; you may sometimes want two adjacent colours to be close in tone so that they sit easily together. An example might be the spaces between bricks or stones on a building; if you make these too dark they will jump forward in space and destroy the coherence of the wall.

Sky and shadows

Shadows can play an important part in the tonal pattern of a sketch and provide a useful three-dimensional effect, although they are not the only tones you will see. The buildings themselves may have varying textures that reflect light differently, and there may be dark accents such as windowpanes, dark-painted doors, and so on. If you are bringing in a dark-tone cast shadow,

Tonal value chart *To make a tonal value chart, divide a sheet of watercolour paper into five even squares and number them one to five. Leave the first square white. Using Payne's grey, paint the second square in a very light tone and gradually darken the following squares until number five is as dark as possible (you may need two coats for this).*

1 2 3 4 5

left overhead

front behind

perhaps in the foreground, look for ways of balancing this with smaller areas of dark elsewhere, or the drawing will look half-finished.

The sky can also be important in the context of tone. If there are dark tones on the building itself, it is wise to keep the sky fairly light in value, but if your subject is a white building set against a deep blue sky, as in Spain or Greece, for example, you can emphasise the whiteness by exaggerating the tone of the sky, whether you are working in monochrome or colour.

Light and shade
The strength of light and the angle that it hits a building will have an impact on the tonal value. Shadows will fall from one building to the next, uniting the image.

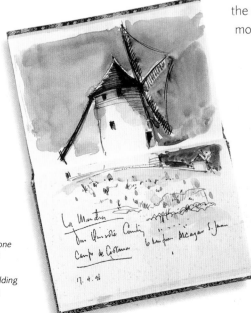

Using the sky
Exaggerate the tone of the sky to add contrast to your sketch. If the building is light, make the sky darker, and vice versa.

EXERCISE 2

Small-town drugstore
by Jim Woods

When you start to make sketches of buildings, try to be open to a wide range of subjects. People often look for the picturesque, preferring old buildings to new ones, and rating churches higher than shops or ordinary dwellings. This drugstore may not be an obviously glamorous subject, but it appealed to the artist because he saw it as typical of American small-town life. It also provided him with the opportunity to practise drawing in

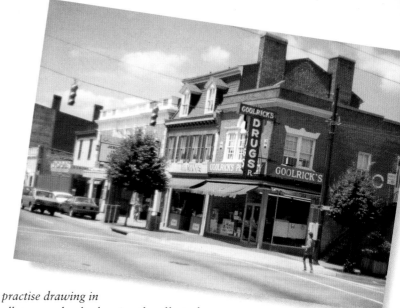

tone, as well as very clearly showing the effect of two-point perspective (see pages 52–53). The eye-level, or horizon line, is more or less at the same level as the head of the solitary figure you can see in the photograph. A useful fact to bear in mind if you intend to include people in your sketches is that their heads will all be roughly at the same level on the horizon line.

Practice points

- MASTERING TWO-POINT PERSPECTIVE
- ANALYSING TONE
- HATCHING AND CROSS-HATCHING
- RESERVING HIGHLIGHTS

STAGE 1
PLACE THE SUBJECT

■ The first decision to make when you begin a sketch is how much to include. The best way to decide on the composition, and see how the sketch will sit on the paper, is to hold up a viewfinder and move it around until you have framed the view to your satisfaction. You may also find it helpful to draw the first lines through the viewfinder, thus relating them to the edges of the paper. Block in the main lines with a 3B pencil, varying the pressure slightly to make some darker than others.

Take care with the proportions, and if you are not sure of the height-to-width ratios, check them by holding up a pencil and sliding your thumb along it. Notice that you can see very little of the light side of the chimney stack because it is receding from you.

Draw this dividing line between the light and dark areas as one continuous line at this stage. In fact, it is broken by the roof overhang, but you can add this in the next stage.

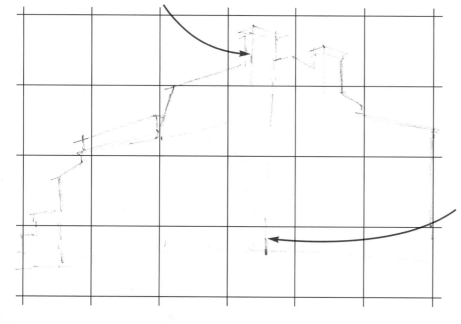

STAGE 2
BUILD UP THE DRAWING
■ Before you can start adding tone, you must have all the salient details in place. It is much trickier to erase areas of tone than single lines, so take the drawing slowly at this stage, erasing if you need to. Observe carefully, constantly checking one area or feature against another, but don't become too bogged down in small detail. To keep the paper clean, rest your working hand on a piece of paper towel or tissue; a 3B pencil is quite soft enough to smudge easily.

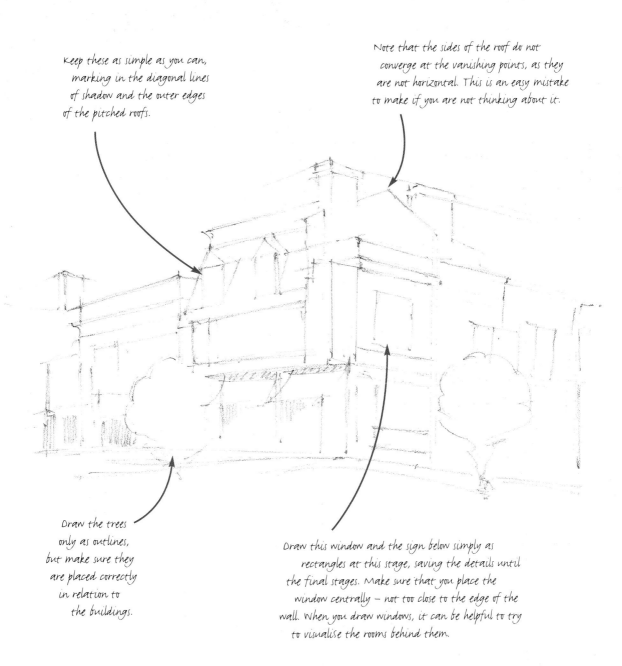

Keep these as simple as you can, marking in the diagonal lines of shadow and the outer edges of the pitched roofs.

Note that the sides of the roof do not converge at the vanishing points, as they are not horizontal. This is an easy mistake to make if you are not thinking about it.

Draw the trees only as outlines, but make sure they are placed correctly in relation to the buildings.

Draw this window and the sign below simply as rectangles at this stage, saving the details until the final stages. Make sure that you place the window centrally – not too close to the edge of the wall. When you draw windows, it can be helpful to try to visualise the rooms behind them.

STAGE 3
LOOK FOR TONE

■ The drawing has now progressed to a stage at which you can begin to build up the tones. There are various ways of adding tone in a pencil drawing; you could, for example, smudge it with a finger, but this tends to be rather messy and imprecise. Hatching and cross-hatching are more suitable for architectural subjects and can create a good variety of tones depending on the pressure of the pencil and on how many lines are laid on top of one another. Start by partially filling in the bottom windows with vertical hatching.

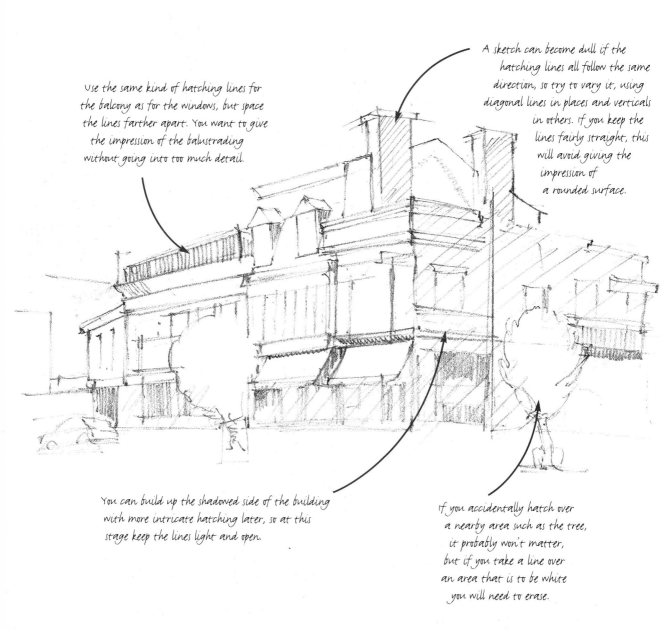

Use the same kind of hatching lines for the balcony as for the windows, but space the lines farther apart. You want to give the impression of the balustrading without going into too much detail.

A sketch can become dull if the hatching lines all follow the same direction, so try to vary it, using diagonal lines in places and verticals in others. If you keep the lines fairly straight, this will avoid giving the impression of a rounded surface.

You can build up the shadowed side of the building with more intricate hatching later, so at this stage keep the lines light and open.

If you accidentally hatch over a nearby area such as the tree, it probably won't matter, but if you take a line over an area that is to be white you will need to erase.

STAGE 4
FINAL STAGES

■ Keep a few areas of the drawing white, such as the window details on the right side, so if there are any stray hatching lines, erase them before you continue building up the tones. For the darkest parts of the picture, use the pencil heavily and lay two or even three layers of lines, varying them so that some are vertical while others are a combination of diagonal and vertical. Where you want really dark near-black tones, as on the window above the awning, make the vertical hatching almost solid, but don't overdo these darks or the drawing may begin to look spotty.

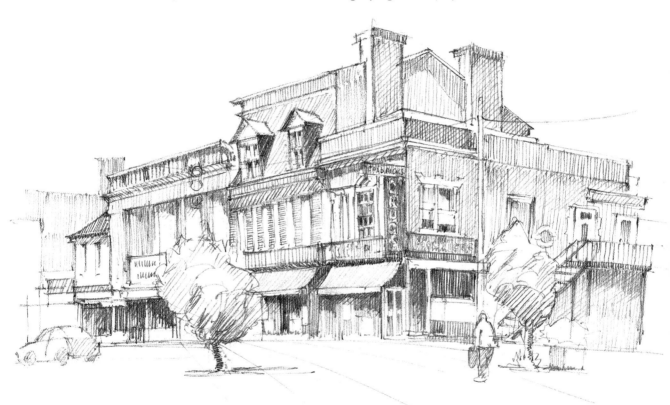

Add a few darker lines and rectangular shapes to the original vertical hatching to give the impression of balustrading without being too detailed and specific.

If you include dark diagonal hatching that follows the line of the roof, it will contrast well with the spaced vertical hatching above and below.

Loosely sketch the trees. As shapes they play an important part in the composition, but if you were to deal with them in detail they would take attention from the building, which is the main subject. The same applies to the figure and the car.

The letters on the sign can be 'reserved' as in watercolour work, by drawing around them. First make light outlines of the letters and then hatch carefully around them with vertical lines.

Other monochrome media

Although ordinary (graphite) pencils are the best known and probably most used of all drawing media, there are many others that can be used for sketching, one being the carbon pencil, which is a form of compressed charcoal enclosed in the same type of wooden case as other pencils. Remember, monochrome drawings don't have to be grey or sepia; a monochrome sketch can be any colour, as long as you use the tonal values within that colour range.

Carbon and other pencils

Carbon pencils are made in different grades of softness; check with your art shop or mail-order catalogue for the different categories. Carbon pencils produce a lovely sensitive line as long as they are kept to a very sharp blade, and the black can be intensified by working on slightly damp paper. They are also useful for drawings later to be coloured, because, when washed over with watercolour, they bleed slightly into the colour to produce very subtle shades. Charcoal pencils and conté pencils are rather similar, though charcoal pencil is easier to smudge and conté pencil is harder to erase.

Dry media
Graphite and carbon pencils are often used for sketching, and carbon pencil can be used with water for a soft effect. Charcoal is sponteneous but messy, whereas conté crayon is a little more greasy and less prone to smudging.

Charcoal and conté crayon

Charcoal itself is a delightful medium to use, though it smudges too readily to be of much use for small, precise drawings. For large-scale work where tone is important, its softness is an advantage, as you can build up large mid-tone areas.

If you intend to

Castle in crayon
Sanguine conté crayon is a good choice for this sketch of a French castle.

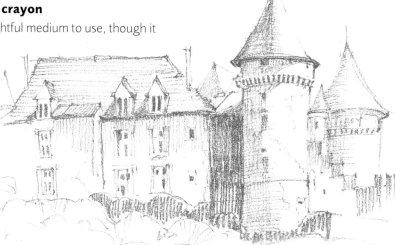

use charcoal, include a can of fixative (or hair spray) in your sketching kit, as you may need to fix the drawing as you work and certainly when you have finished. Conté crayon may also need to be set (or sealed) on completion, though it is harder than charcoal, and so doesn't smudge to the same extent. Both conté crayons and the pencil version mentioned above are good sketching media, though they are hard to erase.

Café noir *Pen and ink enables artists to work quickly and spontaneously, yet with enough detail to add character.*

Pens and inks

There are so many types of drawing pen now on the market that it is virtually impossible to itemise them all, but fortunately most art shops allow you to try them out by scribbling on a pad, which is probably the best way to choose. Some artists like the old-fashioned dip pen with interchangeable nibs, but this involves carrying ink, which can be hazardous for outdoor work. It is probably best to start with a felt-tip pen, or with two – one fine-tipped and one thicker.

You will also have a choice between waterproof and water-soluble. With the former, you can lay colour over the ink without disturbing it, but a water-soluble pen will run when you brush over it with paint or water, which enables you to create line-and-wash effects without carrying paints or bottles of ink.

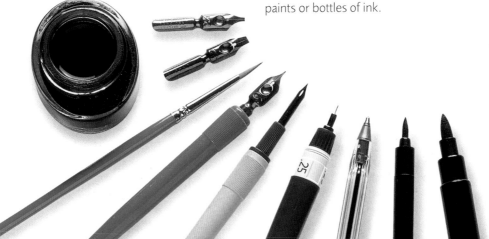

Wet media
Pen and ink make a spontaneous line. Choose between water-soluble and waterproof ink, depending on the effect you are looking for.

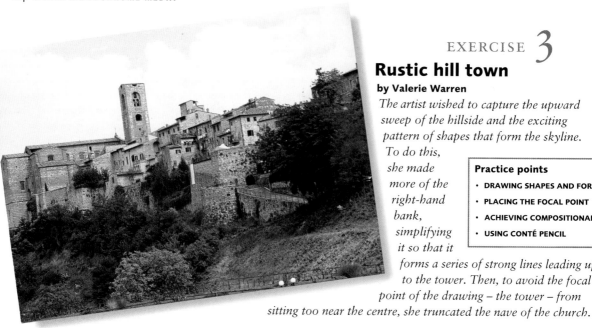

EXERCISE 3

Rustic hill town
by Valerie Warren

The artist wished to capture the upward sweep of the hillside and the exciting pattern of shapes that form the skyline. To do this, she made more of the right-hand bank, simplifying it so that it forms a series of strong lines leading up to the tower. Then, to avoid the focal point of the drawing – the tower – from sitting too near the centre, she truncated the nave of the church.

Practice points
• **DRAWING SHAPES AND FORMS**
• **PLACING THE FOCAL POINT**
• **ACHIEVING COMPOSITIONAL RHYTHM**
• **USING CONTÉ PENCIL**

STAGE 1

STARTING THE DRAWING

■ Using a sanguine conté pencil, draw in the main building blocks, paying particular attention to the silhouette of the tower and rooftops and to the upward sweep of the hillside. Work lightly at first, increasing the strength of the line when you are sure of the placing of the main features.

Indicate the occasional roofline and one or two windows and doors to provide a kind of 'punctuation mark'.

These tall trees on the skyline complement the tower and tall house and stress the vertical emphasis of the composition.

The nave of the church, slightly shortened to accommodate the slope leading up to it, is echoed by the high-roofed house on the right.

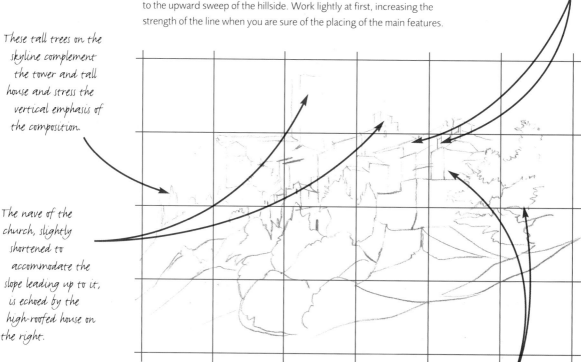

Try to bring some rhythm into the composition by contrasting the curves of the trees with the geometric shapes of the buildings.

STAGE 2
INTRODUCE TONE

■ Now you can begin to bring in tone on the key parts of the composition and emphasise the line in places, making any other small alterations you think are necessary.

Indicate the shaded and partly shaded areas of the buildings and bring in a touch of detail on the tower.

Treat this area in a fairly abstract way, using line to suggest a series of shapes.
If you need to change the foreground later you can remove these lines with a putty eraser.

Strengthen the lines on the hillside to make it more specific and draw a small tree to give a little weight to the foreground and separate the two areas.

STAGE 3
CONTRASTING TONES AND EDGES
■ Now that the main shapes are in place, you can really begin to enjoy yourself, building up the full pattern of light and shade, and exploiting contrasts of shapes and edges.

Work the shaded sides of the buildings with vertical hatching strokes, varying the tones but bringing in enough darks to balance the tones of the tower.

The contrasts of both tone and texture give an extra punch to this central area of the drawing.

Leave most of this tree as white paper, making small dark marks at the edge to indicate the foliage.

STAGE 4
BUILD UP TONE AND DETAIL

■ Add more shading to build up the forms and contrasts, and then you can finally turn your attention to the details. The doors, windows, patterns of roof tiles and so on are very important, as they give clues about the place and the local building styles, but you also want to give the impression of a real town in which people go about their daily lives, so don't ignore small touches such as laundry hanging over balconies. As you draw each line, alter the pressure on the pencil so that the strokes are not all uniform in thickness and tone; this gives the drawing more life and vitality.

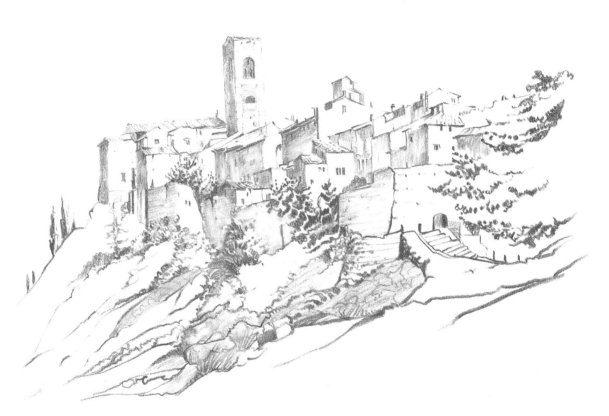

Take care with the shapes and proportions of the windows and suggest the textures of walls and roofs with light line. smudge areas of tone in places in order to draw lines over them.

The laundry adds a touch of human interest, but it also plays a part in the overall tonal pattern, providing a small area of counterchange – light against dark and dark against light.

shade these areas in a mid-tone to tie in with the buildings, leaving the tree as an unspecific shape. This tone makes the white foreground come forwards, pushing the town back in space.

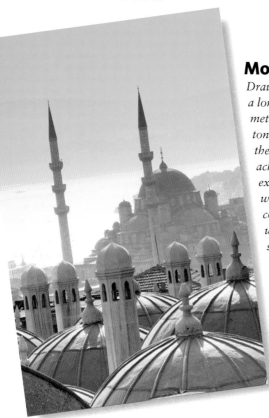

Mosque roofs by David Arbus

Drawings done in pen and ink alone can become fussy and take a long time to complete, as you have to rely on linear shading methods such as hatching and cross-hatching to build up areas of tone. But if you use ink – which can be diluted with water – for the mid- and dark tones, and line for the details, you can achieve a great deal in a relatively short time, creating an exciting and atmospheric effect. The artist is working on watercolour paper and is using water-soluble sepia ink combined with two art pens, which take cartridges of water-soluble black ink.

Practice points

- DRAWING WITH PEN AND INK
- CREATING TONES WITH INK WASHES
- MEASURING TO CHECK VERTICALS

STAGE 1

THE FRAMEWORK

■ Make a pencil drawing first to place the main elements, taking care to make the verticals truly vertical. Sometimes you can get away with a slight lean to one side, but in this case the tall, elegant minarets are a focal point in the composition and need to be accurate.

If you have trouble drawing straight verticals, measure from the edge of the paper to various points and make little marks. You can ensure that the balconies fall at the same height on each minaret by drawing horizontal guidelines.

Look carefully at the domes to check where they intersect one another.

STAGE 2
BUILD UP THE DRAWING

■ Begin with the sky: use a light wash of well-watered sepia ink to show the haze over the minarets.

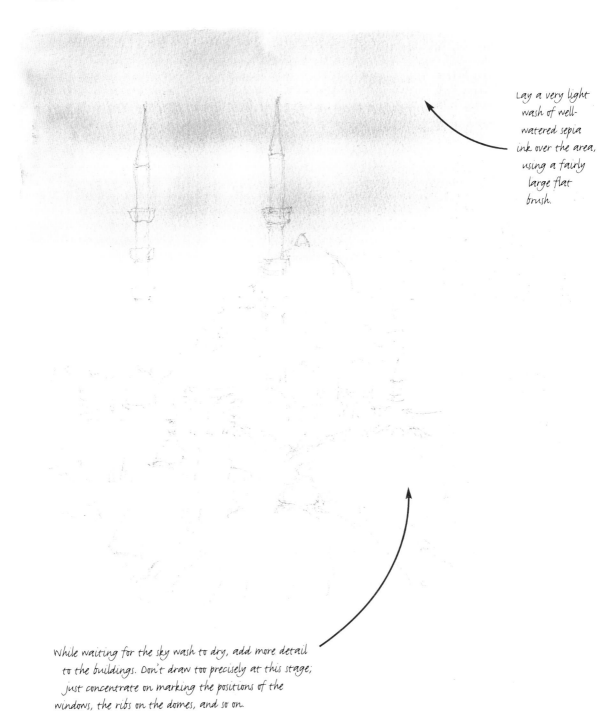

Lay a very light wash of well-watered sepia ink over the area, using a fairly large flat brush.

While waiting for the sky wash to dry, add more detail to the buildings. Don't draw too precisely at this stage; just concentrate on marking the positions of the windows, the ribs on the domes, and so on.

STAGE 3
COMBINE PEN AND WASH

■ Go over the pencil lines with a fine pen, then erase the pencil lines before laying on more ink washes. You will be working from light to dark, as in watercolour, so start with the palest areas, notably the distant trees on the right and the suggestion of a building on the left.

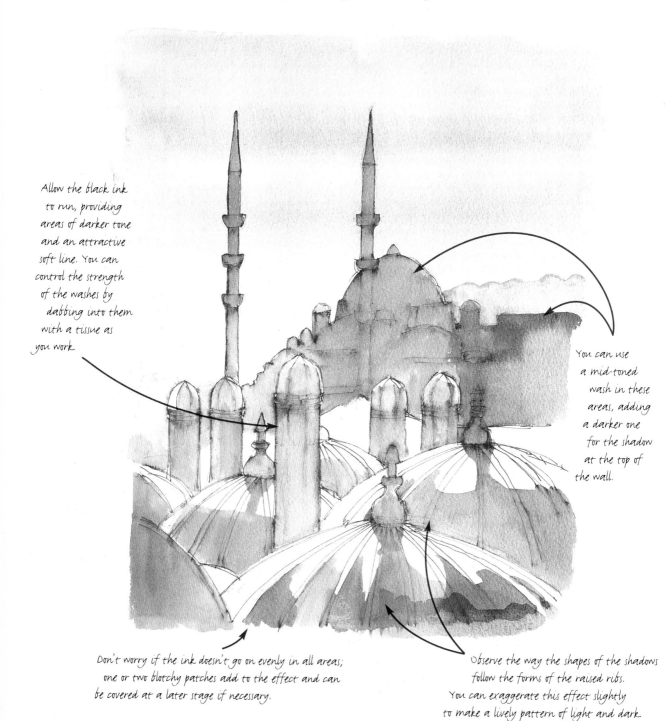

Allow the black ink to run, providing areas of darker tone and an attractive soft line. You can control the strength of the washes by dabbing into them with a tissue as you work.

You can use a mid-toned wash in these areas, adding a darker one for the shadow at the top of the wall.

Don't worry if the ink doesn't go on evenly in all areas; one or two blotchy patches add to the effect and can be covered at a later stage if necessary.

Observe the way the shapes of the shadows follow the forms of the raised ribs. You can exaggerate this effect slightly to make a lively pattern of light and dark.

STAGE 4
ADD TONES AND DETAIL

■ When the first washes have dried, you can add some darker tones in the middleground and foreground and, where appropriate, redefine some of the lines that have been washed out. In this kind of drawing, line and brushwork are used hand in hand rather than at separate stages.

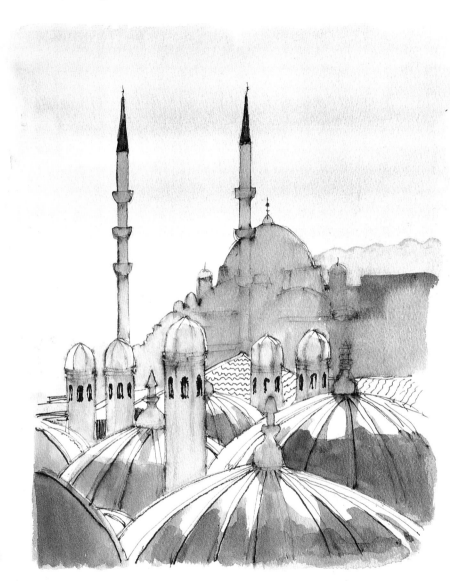

Add detail to the roofs and minarets in the foreground and leave the buildings in the background in soft silhouette.

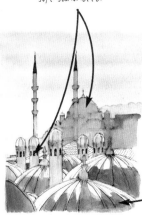

The shadows in the foreground are much darker than those in the distance, emphasizing the aerial perspective (see pages 52–53).

THE FUNDAMENTALS

Drawing with colour

The choice of tools and materials for colour sketching depend very much on the way you work, how large the sketch is to be, and what you want to convey in it, so you may have to try out several different media and drawing implements before finding those that suit you.

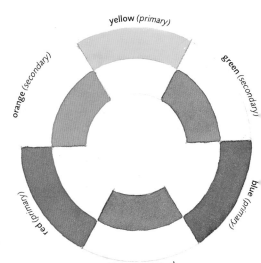

Basic colour wheel *When combined, the primary colours – red, yellow and blue – make up green, orange and purple respectively.*

Coloured pencils and pastels

If you work on a fairly small scale, you may find coloured pencils ideal. They come in a large range of colours, and you can increase the range by laying one over another so that they mix on the paper surface. There is also a water-soluble type, which enables you to wash over the drawn lines with water to create washes or to blend and soften lines. These washes are seldom as intense as ordinary watercolour washes, but they do allow you to create broad areas of colour more quickly than you can with the dry pencils, where you have to use the relatively slow hatching and cross-hatching methods.

Pastel pencils are rather like very soft coloured pencils and are excellent for quick sketches, as you can spread colour quickly by rubbing with a finger and make detailed, decisive drawing with a well-sharpened point. You will need to set them on completion, however, to prevent smudging, and you won't get the best results by working on smooth paper. Pastel needs a bit of a textured surface or 'tooth' to hold the colour, so it is best to use the pastel paper made for the job.

Soft pastels are more suitable for studio work than for sketching buildings outdoors, as they are somewhat messy to use, break easily and lend themselves better to broad effects than to detail. However, not all pastels are soft and crumbly; there is a harder type that is made in square-sectioned sticks like conté crayon. These hard pastels are soft enough to blend and build up areas of colour, but sufficiently tough to remain unbroken in the course of a work session. Again, these are best used on pastel paper.

Dry media *Experiment with soft pastels, pastel pencils and coloured pencils. Don't forget to set any pastel work, otherwise it may smudge.*

Wet media *You can add watercolour to drawn pencil or ink lines, or you can draw with your watercolour brush. Choose whether you want to use water-soluble or alcohol-based felt-tip pens and inks, depending on the effect you wish to achieve.*

Inks and felt-tip pens

Coloured inks are very enticing, as they yield wonderfully clear, rich hues and can be mixed and/or watered down. But they do make a cumbersome sketching kit, and you would have to find a very safe place to work to avoid the risk of spillage – even dipping a brush into a bottle of ink can result in permanent stains on your clothes.

A better bet for sketching is a set of felt-tip pens, which are filled with coloured inks. There are two versions of these – water-soluble and alcohol-based – so check whether or not you can blend with water before buying or using them. The colours tend to be slightly brash, but you can modify them by working one colour over another. You will need a fairly sturdy paper for felt-tips, such as a heavy drawing paper or a watercolour paper, as the colours tend to bleed through to the back of light paper, which may buckle if you are using water.

French scene
This line-and-wash sketch uses fresh colors and lively linework.

Indian summer
You can lay down a wash of colour before you sketch with ink, or you can add wash afterwards. Here, colourful washes of diluted ink have been added after the image has been sketched.

Watercolour

This versatile medium has been used for sketching since time immemorial, and is still one of the most useful ways of adding colour to a sketch. All you need is a small paintbox with ten or so colours in it, a couple of brushes and a water container. If you don't want to carry a drawing board, buy a pad of watercolour paper – these are available in many different sizes and qualities.

EXERCISE 5

Rainbow apartments
by Jane Hughes

This subject is more about purely pictorial values than it is about buildings. Indeed it is not easy to make out the structures, as the angle of viewing stacks the buildings up together. The result is a lovely, almost abstract tapestry of colour, light and shade that simply cries out to be drawn in brilliant hues. Hot sunshine lifts the colour temperatures, even those of the normally cool colours such as green, blue and violet, while the colours at the warmer end of the spectrum – the reds, oranges and yellows – are dramatically boosted. Felt-tip pens are an ideal choice for exploiting this richness to the full. These come in a wide range of colours, and the ink they contain is either water-based or alcohol-based. Liquid drawing inks, which can be used with either brushes or pens, would be another possibility for a sketch like this.

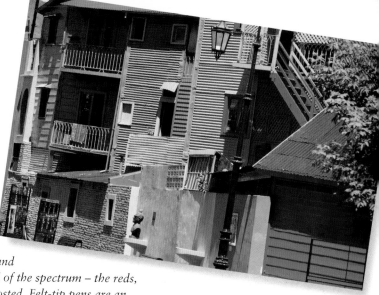

Practice points

- **USING COLOUR TO DEFINE PATTERN AND FORM**
- **WORKING WITH FELT-TIP PENS**
- **BLENDING, OVERLAYING AND BUILDING UP COLOUR**

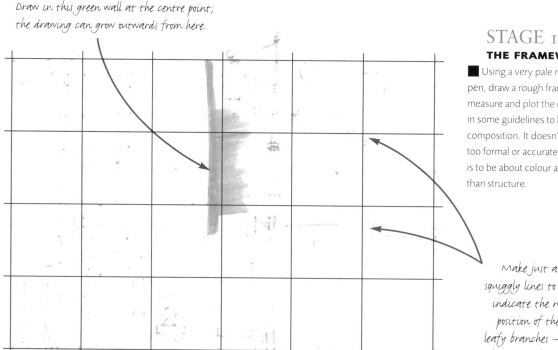

Draw in this green wall at the centre point; the drawing can grow outwards from here.

STAGE 1
THE FRAMEWORK

■ Using a very pale neutral grey felt-tip pen, draw a rough frame to help you to measure and plot the drawing. Sketch in some guidelines to begin the composition. It doesn't have to be too formal or accurate, as the sketch is to be about colour and pattern rather than structure.

Make just a few squiggly lines to indicate the rough position of these leafy branches – at this stage they don't need to be too strongly drawn.

Felt-tip pens come in various shapes and sizes. Choose a fine-tipped one for the basic outlines of your drawing.

STAGE 2
FINALISE THE PLOT

■ As colour is to be the main theme of this sketch, you can use it to define the structural details of the buildings in blocks as well as lines. The colour wheel on pages 32–33 is a good indicator of warm and cool complementary colours. Start with a light shade – it's easier to work over than a dark colour – and block in the appropriate areas.

The drawing will be improved by the addition of some small detail. Block in yellow for these little balconies, leaving white paper for the hanging clothes. The rails will be defined later by colouring in the spaces between them, working over the yellow.

You can use a broad or wedge-tipped pen to cover a large area fairly evenly.

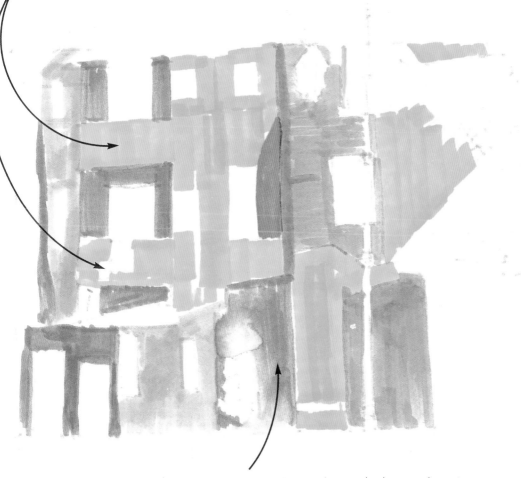

Some pens enable you to make a wash: dip a brush or your finger in water (use lighter fluid for alcohol-based pens) and rub over the pen marks. It doesn't always work, so try it out on a spare piece of paper first.

STAGE 3
BUILD UP COLOUR AND PATTERN
■ The underlying drawing is almost complete, and you can now begin to draw in the different textures of the walls, working over the base colours and making a variety of marks.

As the inks are transparent, colours can be laid over one another to produce quite subtle gradations of colour and tone. A pen with a flexible, paintbrush-shaped nib is good for more flowing, expressive marks.

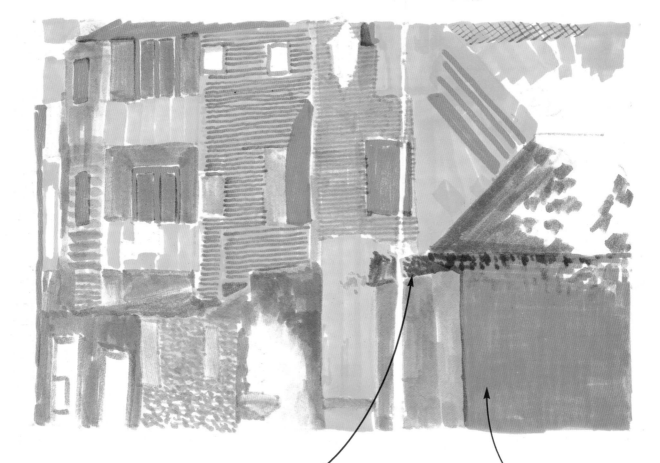

Complementary colours stippled over one another add depth to shadow areas.

Give red additional warmth by overpainting it with yellow.

STAGE 4
KNIT IT TOGETHER

■ The blocks of colour, still quite abstract in appearance, can now be given
more coherence by building the shadow areas across the whole picture. You can
use complementary colours to make a harmonious contrast of light and shade.

To build up the shadows –
especially below the balconies
and the overhanging roofs – lay
on layers of pale violet, the
complement of yellow.

Block in the leaves
loosely with several
shades of green and
yellow to give a
contrasting texture to
that of the buildings.

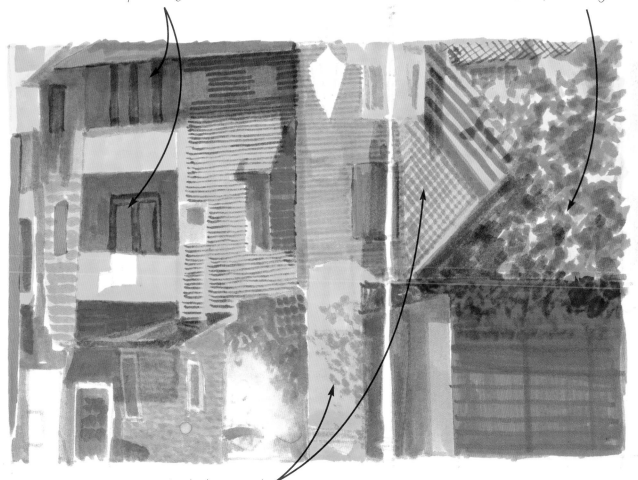

Develop the shadow detail
across the whole picture,
using a variety of marks.

STAGE 5
TONAL BALANCE

■ The basic colours are now in place, but the tones need to be deepened in places, not only to describe the buildings but also to enhance and strengthen the pattern and suggest the play of light. In bright sunlight, the tonal contrasts are much greater than they are in diffused sunlight or an overcast day, and this wide tonal range creates a rich and varied texture.

Draw the sloping rails of the staircase by working up to their edges. Use dark green over the reddish areas and blue-violet over the yellow ones.

Use a dark violet to strengthen the deep shadows in the window frames and beneath the balconies.

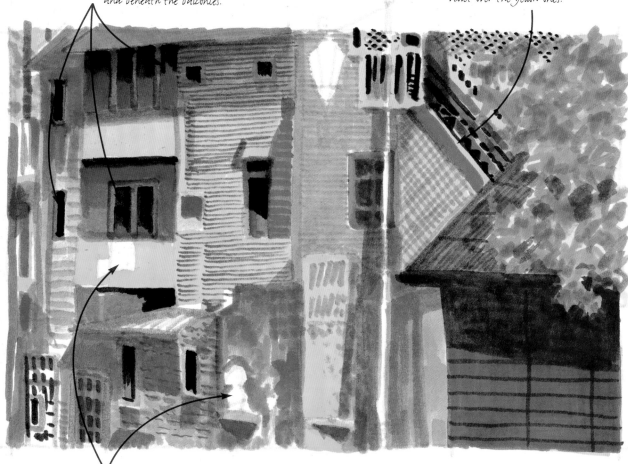

Any bits of white paper still visible at this stage were intended for last-minute details, so leave these until the final stage, but try to make the rest of the drawing as fully coloured as possible.

Adjust the colours and shadow details as you work across the picture; check one area against another so that you achieve a good balance.

STAGE 6
FINAL ADJUSTMENTS

■ *All that remains now is to make a few finishing touches, such as the bust and the laundry hanging over the balcony. So now you can finally fill in those small bits of white paper as well as complete the details of the balconies and add one or two final dark accents.*

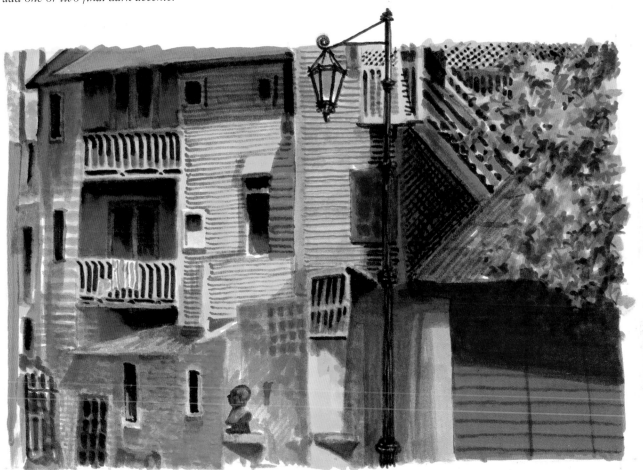

Draw into the negative spaces between the balcony rails, matching the colour to the shaded walls beyond them. Don't forget the towel hanging over the rail – a detail that adds atmosphere to the sketch.

This lamp is one of the few features in the picture which is not actually a part of, or resting on, the buildings. However, its position, combined with the lighting, make it appear very flat, almost as though it were set flush into the surface.

This stern portrait strikes a different note, the aged bronze making a small-scale but significant contrast to all the other clear, bright colours.

Add a little more depth by darkening the shade below this roof and also in the leaves.

EXERCISE 6

Onion spires by David Arbus

The majority of building subjects in Europe and America are relatively muted in colour, and although some Victorian buildings do sport wonderfully colourful decorative schemes, these are mainly confined to the interiors. But as you travel towards the East, the building styles become increasingly lavish and highly decorated, with golden onion domes in Russia and spectacular glazed and painted tiles covering the mosques in Muslim countries. You could not do justice to such subjects with a monochrome medium, and for this one, the artist has chosen watercolour combined with water-soluble pen.

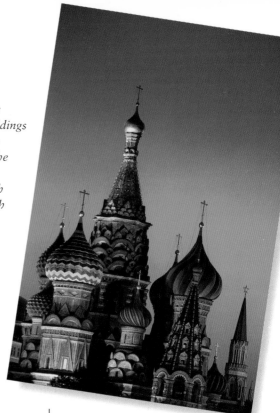

Practice points

- DRAWING UNUSUAL SHAPES
- BUILDING UP PATTERN AND DETAIL
- PAINTING WITH COLOURED INKS
- CREATING TONE WITH WATER-SOLUBLE PENS

STAGE 1
THE DRAWING

■ Working on watercolour paper, start with a light pencil outline of the main shapes. Since this is a very complex subject containing shapes that will probably be unfamiliar to you, such as the onion-shaped domes, you could make a squared-up drawing as explained on pages 10–11, carefully erasing the grid lines when the drawing is complete.

Make sure you draw the dome complete with the finials, as you will be taking the first watercolour wash around these.

If you make a mistake, just draw another line lightly over the first. This is often better than erasing the incorrect one, because if you don't have this as a guideline you may simply repeat the mistake.

Don't work right up to the edges of the paper; if you leave some white paper outside the drawing area, you will have a choice of whether to leave the edges rough or to crop into the sketch when complete.

STAGE 2
COLOUR AND PEN DRAWING

■ The almost unbelievable red sky is to form an important feature of this sketch, reinforcing the exotic atmosphere. Wash this in with Winsor red, taking the colour carefully around the domes and finials and the spire on the right. When this wash is dry, draw over the pencil lines with a fine-nibbed water-soluble art pen.

When a wash is taken around complex edges it doesn't always go on completely evenly, but don't worry about this, as a slightly blotchy effect will give character to the drawing.

Make small wiggly lines here rather than straight ones to suggest the encrustation of raised pattern. some of the ink will run when the next watercolour washes are applied, softening the lines.

Don't try to make the ink lines too precise or mechanical. Try to work freely while bearing the main shapes in mind.

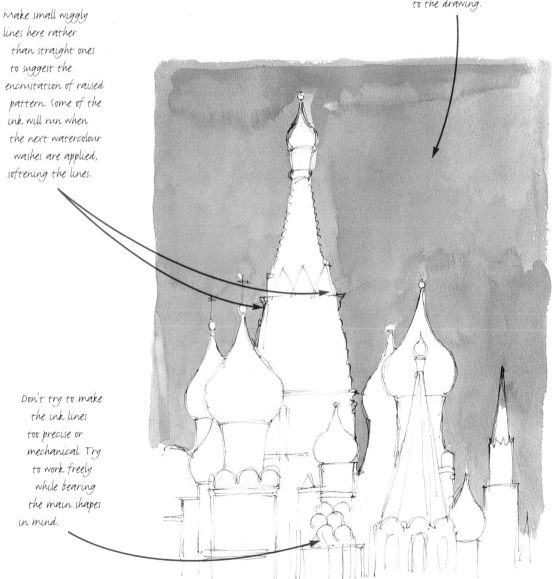

STAGE 3
BUILD UP THE COLOURS

■ Watercolour is usually worked from light to dark, laying the palest washes first. Start with diluted washes of raw sienna and yellow ochre, and let these dry before continuing to build up the colours.

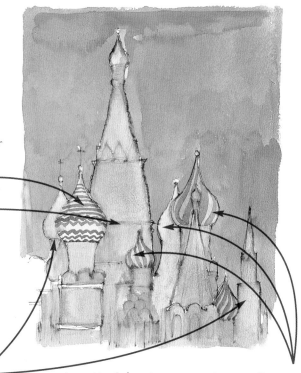

Paint the stripes and dogtooth pattern with Winsor red and chromium oxide green, but this time make the colours stronger.

This yellow-brown is a warm colour that sets the key for the other colours, and it is light enough to allow for darker detail to be painted on top.

Paint over this previously unpainted area with the same green used for the domes. Notice how it appears much clearer and bluer when it is laid on white paper.

Using oxide of chromium green, paint curvy lines over these three small domes. The underlying wash shows through the green, dulling it by producing a mixture of the two colours.

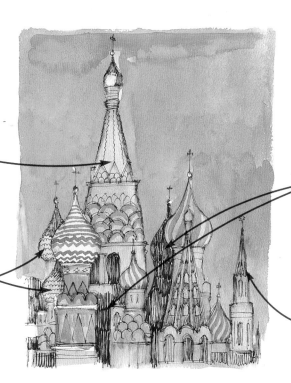

Keep the lines light and sketchy here, aiming to give an impression of the pattern without drawing each element too precisely.

Use vertical hatching lines for the dark top and loose squiggles below, taking care to make these follow the form of the dome.

STAGE 4
STRENGTHEN THE PEN DRAWING

■ Now that the main colours are in place you can begin on the fun part of the sketch, which is drawing in the wonderful array of detail and beginning to build up the tones to give the drawing more punch.

The great advantage of working with water-soluble pens is that you can create tone very easily by washing over the lines with water. Start with vertical hatching in all the darker areas.

Draw the light shapes first and then make hatching lines around them, following the lines of the roof.

STAGE 5
COMPLETING THE DRAWING

■ The final stage is to paint in the darkest tones and reinforce the colours in one or two places. With the drawing complete, you can then decide whether to leave the edges uneven or to crop in. Artists sometimes enhance the looseness of a drawing like this by cutting the mat (mount) outside the edges of the drawing.

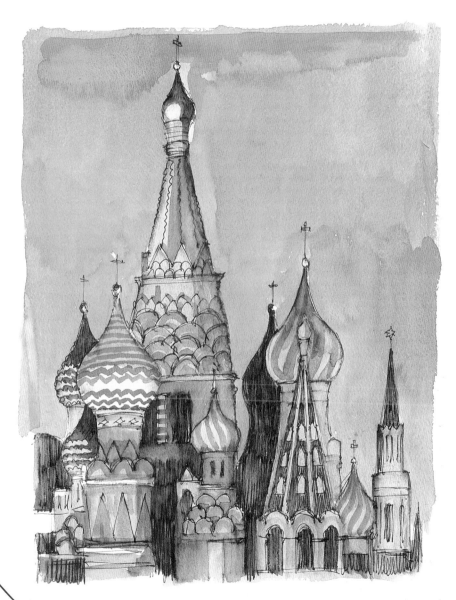

To create the tone, all you need to do is to wash over the hatching lines with water. The tones will vary according to the spacing of the hatching lines.

Add just a touch of raw sienna to the wash water in places to warm the grey a little.

The impact of the drawing stems as much from the tonal pattern, with very dark tones set against mid-tones and small areas of near-white, as from the shapes and patterns seen in the subject.

Cityscape by Michael Lawes

Modern block buildings and skyscrapers may not be everyone's choice of subject, but a scene like this has great potential, allowing the artist to exploit the semi-abstract pictorial values provided by the interplay of strong geometric shapes. The reflections, which echo the shapes of the buildings, allow the dominant verticals to be taken right down to the bottom of the picture, and the artist makes the most of this opportunity by exaggerating them slightly, and playing down the shapes of the central boats. He also departs from strict reality in his choice of colours, bringing in complementary colours such as red and green to give the picture an extra sparkle. He is working with pastel pencil on watercolour paper, which has enough texture to break up the strokes, giving an attractive texture to the drawing.

Practice points

- USING PASTEL PENCILS
- DRAWING GEOMETRIC SHAPES
- EXPLOITING COMPLEMENTARY COLOUR CONTRASTS

Use Indigo and dark blue-grey to shade the sides of the buildings, varying the tones by increasing or decreasing the pressure.

STAGE 1
LINE AND TONE

■ Start with a light pencil drawing to place the main elements and then begin to indicate the darker areas of tone by making diagonal hatching strokes with a pastel pencil. Although graphite pencil tends to repel the pastel colour laid on top (graphite is slightly greasy) and is not recommended for use with soft pastel, pastel pencils are hard enough to cover the marks.

Draw in the boats on the left and right sides of the picture with indigo. Those in the centre are to be left just as light suggestions rather than treated in detail.

Mark in the masts and their reflections with indigo and repeat the dark blue-grey of the buildings in the reflections of the buildings, making sure that they fall directly below the buildings themselves.

STAGE 2
ESTABLISH THE COLOURS

■ Block in the sky and water next, as these large areas of blue will provide a key to help you choose the colours and tones for the buildings. It is very difficult to assess colours if the background is left as white paper, because almost all colours look too dark or too bright by contrast.

Use dark ultramarine blue for these areas, making vertical hatching strokes to reinforce the vertical emphasis of the composition.

Use yellows and ochres for these to ensure that they sing out against the blue of the sky — yellow is the complement of blue.

Use a bluish green and a red-brown for these two buildings to introduce a complementary contrast.

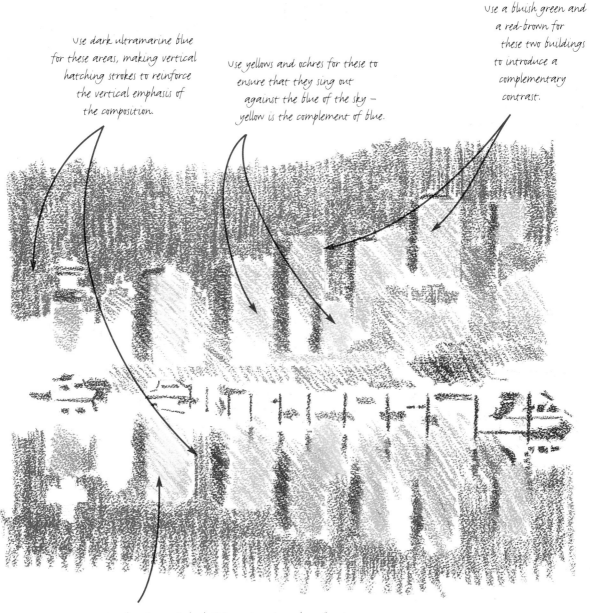

Take the colours of the buildings down into the reflections, again using diagonal hatching lines.

STAGE 3
BUILD UP THE COLOURS

■ Continue to add colour to the sketch, using complementary
contrasts wherever possible. For example, yellow and mauve
complement each other, so use mauve for the boats and their
reflections. When you have done this, begin to suggest the details
of the buildings, repeating these in the reflections.

*Use darker tones of the
building colours, plus
dark blue in places, to
draw horizontal and
vertical lines representing
spaces between windows
and floors on the fronts of
the buildings.*

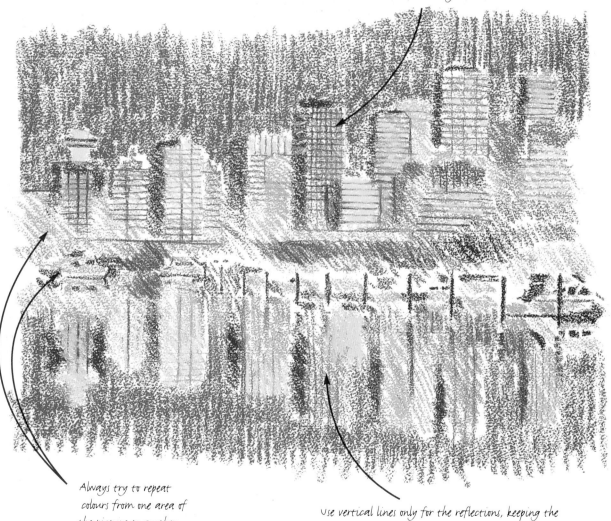

*Always try to repeat
colours from one area of
the picture to another
to create unity.*

*Use vertical lines only for the reflections, keeping the
lines softer than on the buildings and letting them
fade away at the bottom, blending into the water.*

STAGE 4
STRENGTHEN THE DRAWING

■ All the drawing now needs is a few accents of tone and colour and a little extra definition and contrast. Resist the temptation to overwork the drawing, as pastel is a fragile medium, and this can compromise the quality as well as dulling the colours.

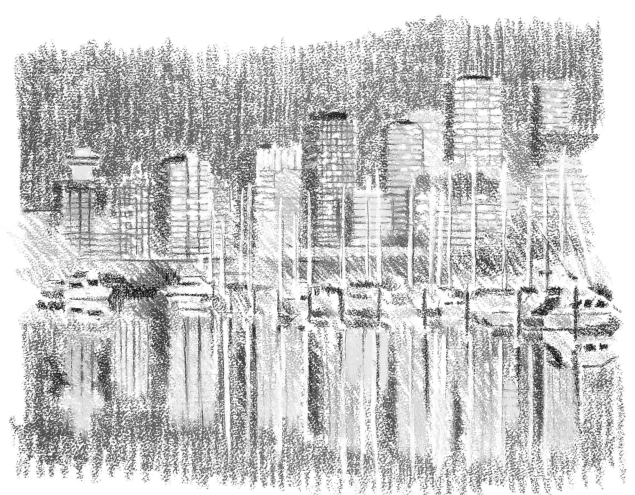

Make a few more dark horizontal lines to suggest the boats. These lines are important to balance the dominant verticals, but don't attempt to draw the boats in detail.

Add touches of vivid colour to suggest the bright artificial light within the buildings. Pastel is an opaque medium and can be worked light over dark, though you will need to exert more pressure to cover the underlying colour.

Blur the bottoms of the reflections by drawing over them with a white pastel pencil, rubbing lightly with a finger if necessary.

Draw the masts in with white pastel pencil and darken the areas behind them to make them stand out.

EXERCISE 8

The pink house by Jim Woods

Both the shape and the colour of this old house in a Spanish town appealed to the artist when he first saw it over twenty years ago, and since then he has revisited the area and made many 'paintings of the pink house', both on-the-spot sketches and finished works. *The tall, elegant proportions could be rendered in a monochrome drawing, but he saw the colour as all-important,* as it conveyed much about the character and atmosphere of the town. He decided on a combination of drawn line and watercolour, and works on watercolour paper with carbon and graphite pencils, watercolour and pen.

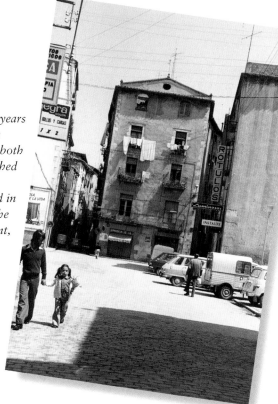

Practice points

- CREATING PICTORIAL UNITY
- RESERVING HIGHLIGHTS
- LETTING THE DRAWING SHOW THROUGH

STAGE 1

THE FRAMEWORK

■ Look at the subject through a viewfinder and decide where you want to place it and how much else to include at the sides and in front of the building. This is very important, as decisions you make at this stage will affect the whole of the painting process. Move the viewfinder back and forth until you are satisfied with the composition and then block in the main lines with a carbon or graphite pencil.

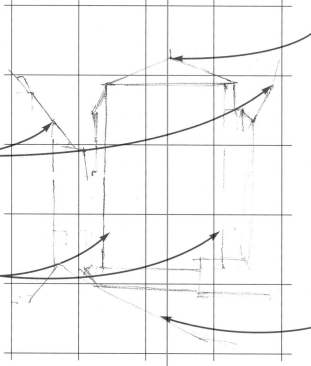

Check these angles carefully, noting that they alter and become flatter as the street bends around.

When a building appears so obviously tall, it is easy to exaggerate the height unintentionally. By all means, take measurements to check, but use artistic licence if you wish to accentuate the shape of the building.

The building is seen from the front, so the point of the roof is central. Make sure of this by drawing a light vertical line down the middle.

The artist decided to introduce a pavement running diagonally from the foreground to the side of the building.

This helps to draw the eye in towards the focal point.

STAGE 2
BUILD UP THE DETAIL

■ Using a well-sharpened soft pencil, start to build up the detail. Carbon and soft graphite pencils smudge easily, so keep your work as clean as possible. Observe very carefully as you draw in the windows, chimneys and so on, and take measurements as you go.

Take care with the spaces between the windows; there is considerably more space in the centre than at the sides.

Draw these simply as rectangular shapes at this stage, again taking care with the proportions.

The windows at the top are smaller than those below; both windows and balconies become larger and grander towards the bottom of the building.

STAGE 3
FINALISE THE DRAWING

■ Continue to work up the drawing, looking for any interesting details such as the stone quoins at the edges of the walls, the balconies, windows and shutters. Don't worry that you may have too much line and detail (some watercolour painters start with just a few very light lines), because drawing and colour go hand in hand in this sketch. Some of the original lines will be left to show through the paint to be reinforced later with more line work.

These windows can be drawn as little more than a double pencil line, but make sure they follow the lines of the roofs.

Draw these shapes carefully, as they are to be reserved as white paper when you start to paint.

start with a wash of raw sienna and a touch of alizarin crimson. Let this dry and then strengthen it in places. The small hard lines that form where the wet paint is worked over the dry help to describe the rough texture and uneven surface of the wall.

For these buildings, use raw sienna alone, in a fairly weak mixture, and leave to dry before painting the shadow.

STAGE 4
PUT ON THE FIRST COLOURS

■ Working freely, lay light washes all over the painting, except for the stone quoins, the windows and the laundry, which should be left as white paper. It helps to use a brush that seems a little too large for the job, as this will make your work look more spontaneous. When the first washes have dried, sketch the shapes on either side of the building before painting them. These are important, as they frame the building and create a three-dimensional effect; buildings seen directly in front can have a cardboard cutout appearance.

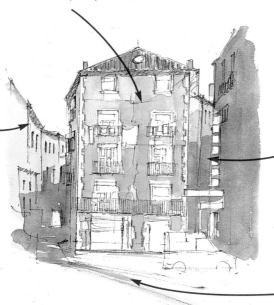

Paint the shadows with a mix of sepia, burnt umber and ultramarine blue. The colours will vary slightly according to the base colour they are laid over, appearing slightly more yellow on the left side.

Paint the curb first in the raw sienna used for the buildings, then take the shadow colour down into this to about halfway.

STAGE 5
DRAWING OVER PAINTING

■ Now use the carbon pencil again to make diagonal hatching lines in the shadow areas. Pay particular attention to the shapes of the shadows under the balconies. When you paint over these, the carbon mixes with the paint to make pleasing shades of grey. Wash over the lines with various mixtures of sepia, burnt umber, ultramarine blue and Payne's grey, and then add some touches of blue-grey to the windows.

When you have painted the shadow beneath the roof, deepen the tone of the overhang by drawing with the carbon pencil and adding a strong sepia, burnt umber and ultramarine blue mixture on top.

strengthen these shadows so that the pale tone of the signs stands out well, and leave the horizontal signs below as white paper.

A painting always hangs together better if you don't use too many different colours, so use raw sienna again for the towel and, with a touch of orange, for the signs on the right. This forms a link with the buildings on the left of the picture.

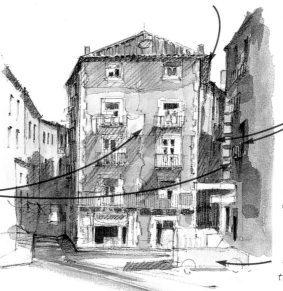

Paint the truck very sketchily, as you don't want it to stand out too much. Use the same blue-grey as for the shadow to the right so that it blends in.

STAGE 6
FINISHING TOUCHES

■ Paint the sky next, using a mixture of indigo and ultramarine blue. It is always tempting in sunlit scenes such as this to paint the sky a bright, clear blue, but in this case the sky is little more than a backdrop, acting as a foil for the lovely, clear colours of the building, and thus should not be too vivid.

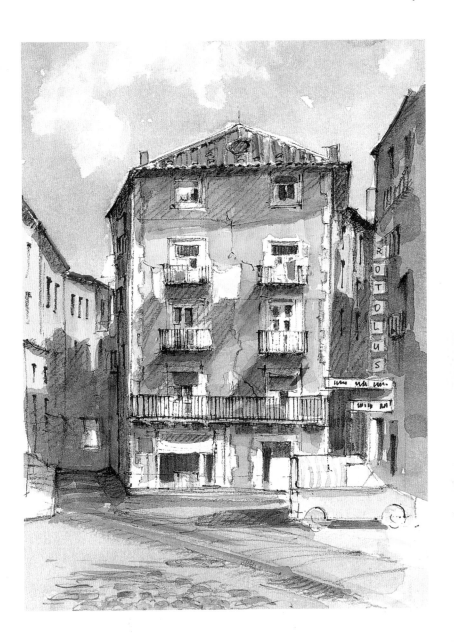

Repeating the same or similar colours from one area of the picture to another ensures that it hangs together as a whole. When you choose colours, always keep the idea of pictorial unity in mind and don't suddenly introduce a lot of new colour in the final stages – except maybe in this case, just a touch of colour to some of the laundry to add interest to what is a small but focal point of the sketch.

Before the wash for the sky has dried, blot out some of the paint with a tissue to give the impression of clouds.

Use a black pen for the lettering on these signs and draw them fairly freely. If you were to attempt painting them in with a small brush, your work would become tight and fussy, spoiling the free, spontaneous feel of the sketch.

Use touches of pen work here too, and elsewhere in the painting, as appropriate. If you restrict this to one area alone, it will stand out too much and destroy the unity of the picture.

Understanding perspective

Many of the effects of perspective can be easily observed. For example, we can all see that objects appear smaller the farther away they are. Theoretically, anyone with a really keen power of observation should be able to draw buildings in correct perspective without knowing the rules, but it is much easier when you do at least know the rudiments. The basic principles are quite simple and easy to remember.

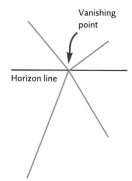

Vanishing point

Horizon line

One-point perspective

The central law of linear perspective is that all receding parallel lines converge and eventually meet at a point known as the vanishing point (VP) on your eye-line. If you are looking down a long, straight road with houses on either side, a series of imaginary lines joining the roofs, the tops of windows and doors and so on will all meet at a single point on a line known as the horizon, which is the level of your own eyes. The houses will become increasingly smaller as they near the vanishing point, and the spaces between them will diminish in proportion.

The important thing to remember is that the horizon line and vanishing point both move with you. If you sit down, your eye level and the horizon line become lower, and if you move to one side or the other the VP will no longer be central. This is why it's important not to change your viewpoint when you draw; even a small change in position will alter the perspective.

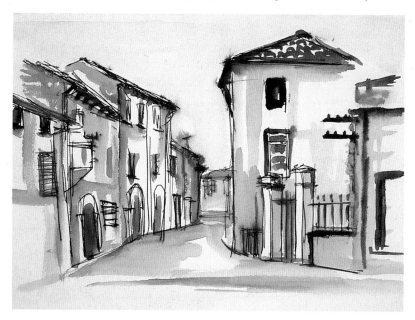

One-point perspective
A classic example of linear one-point perspective. The receding parallel lines meet at one vanishing point, creating a feeling of depth and distance.

Two-point perspective

If you are looking at a house from an angle, you will see two walls, and each will have its own vanishing point. This is known as two-point perspective. Each set of parallel lines – those on the left and right – will meet at a point on the left

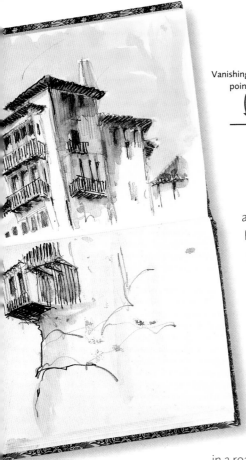

Two-point perspective
The walls of this building become smaller the farther they are from the viewer, like a cube.

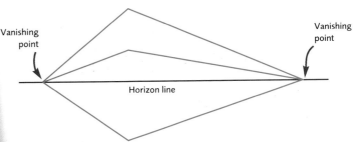

Vanishing point

Vanishing point

Horizon line

and right respectively, but both will still be on the same horizon, or eye-level, line. The nearer the house is to you, the more acute will be the slope of the parallel lines formed by roofs or the tops and bottoms of windows, whereas if the building is in the distance the perspective effect will be much less pronounced. Sometimes you will find that the vanishing points are far outside the edges of your drawing, so you will have to imagine them, but it is always helpful to mark in the horizon line so that you can plot one or two of the more important receding lines. In cases where buildings are set at odd angles to one another, or where bends and turns in a road alter the angles, there may be several vanishing points, but once you have grasped the basic principles you should be able to work these out without too much trouble.

Aerial perspective

This is not really related to linear perspective, but it is equally important to the artist, as it is another way of creating the impression of space and recession. Far-off objects don't just appear smaller as they recede; they also become less distinct, with little visible detail, paler colours and reduced contrasts of tone. Tiny specks of dust in the air collectively make a kind of veil, which becomes progressively thicker with distance. If you are sketching in colour, make the colours paler and bluer, and if you are drawing, sketch distant buildings or landscape features more loosely than those near to you.

Aerial perspective
The buildings and mountains in the distance appear pale and less detailed as a result of the build-up of dust in the atmosphere.

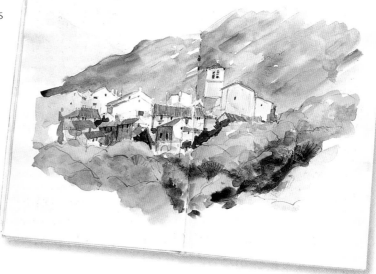

EXERCISE 9

Rooftops by Valerie Warren

Drawing architecture can be intimidating, because it needs to appear accurate, especially if the building is well known.

Practice points
- **CREATING RECESSION BY AERIAL PERSPECTIVE**
- **ORGANISING THE COMPOSITION**
- **LEADING THE EYE IN**

But if you tackle an apparently more complex subject, such as this view over a group of buildings, you can focus less on the exact reproduction of the details and structures than on the composition. To achieve the effect of distance, remember that buildings of a similar size become smaller as they recede in space and also fuzzier in detail, with greatly reduced contrasts of tone. On the skyline, everything is a blurred grey.

Mark in this second outline with its attractive building feature.

Indicate the skyline with the secondary major building, which echoes the shapes of the palace.

Although the buildings are in reality set at random angles, you can rationalise them to provide diagonals that lead the eye into the centre. These are only guidelines and can be erased later.

The palace, with its tower and dome, forms the main focal point. Avoid placing the focal point right in the middle of the picture.

STAGE 1
PUT IN THE GUIDELINES

■ Choose a focal point – in this case the old palace – and pick it out very lightly with a B pencil. Once you have done this, you can organise the medley of other buildings and directional lines pointing towards it, making sure the overall shape is agreeably placed on your paper. When drawing on the spot, it is helpful to use a viewfinder (see pages 66–67) or two L-shaped pieces of cardboard you can put together to make a frame. This helps you to work out how to translate the three dimensions into two.

STAGE 2
FIX THE BOUNDARIES
■ This is the stage at which you can clarify some of the main features, such as the dome on the right of the palace. You can also decide on the outer boundaries of the picture.

Take care with the perspective and structure of the tower and dome, as this is the main centre of interest and will attract most attention.

Draw light vertical dividing lines to give yourself a guide for placing details later.

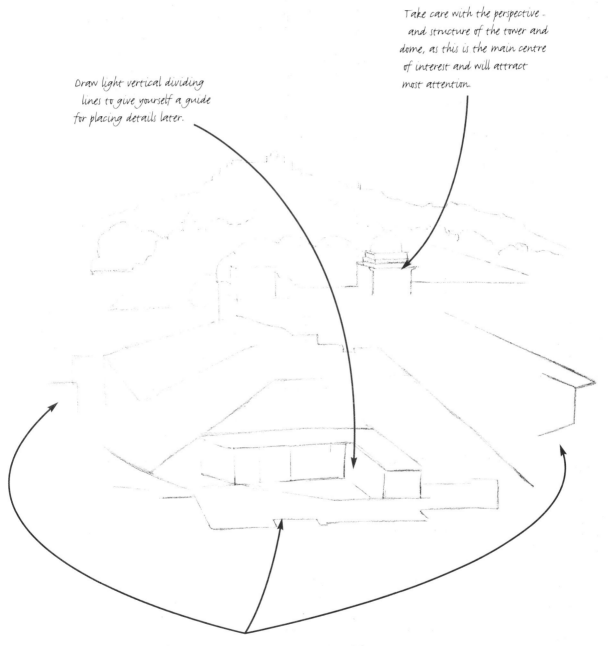

The end of the left-hand façade is suggested, together with the central foreground and the end of the right-hand group of buildings.

STAGE 3
ADD SHAPES TO THE GUIDELINES

■ Using the basic directional lines, build up the picture by indicating the blocking of individual structures. Contrast the flat-roofed cube shapes of the buildings with the curvilinear outlines of trees so that a satisfying balance is achieved.

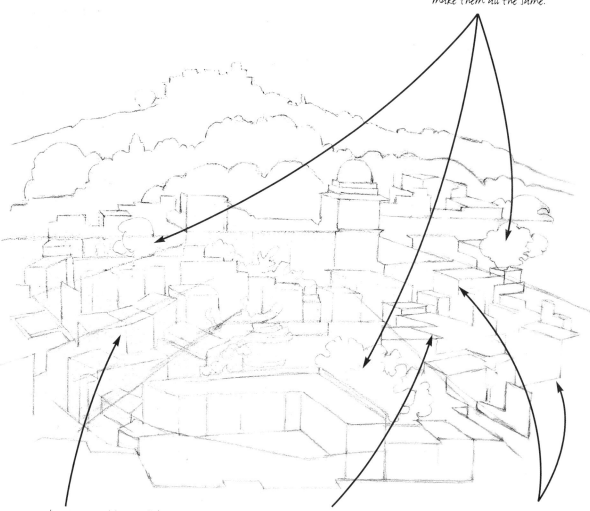

Look carefully at the trees to analyse their shapes; it is all too easy to make them all the same.

The directional lines will have helped to impose a perspective on the jumble, but remember they are no more than guides; the roofs of these three buildings form a curve.

The use of zigzag lines here adds variety to the drawing.

Be sure to keep the verticals truly vertical; use a ruler if it helps.

STAGE 4
BUILD UP THE FORMS

■ At this stage you can begin to make the drawing look three-dimensional by working in tone. First erase the directional lines, which have served their purpose, and then get out a 7B pencil and start to enjoy yourself. Try to see areas of differing tone and remember the effectiveness of counterchange – dark shapes against light ones.

The palace is basically dark against light, but the tones vary from mid-tone to very dark, with the dark areas smaller.

As you work in the tones you will be able to see the drawing as a whole and decide whether changes are needed. The artist has altered the skyline by bringing in hills on the right and left.

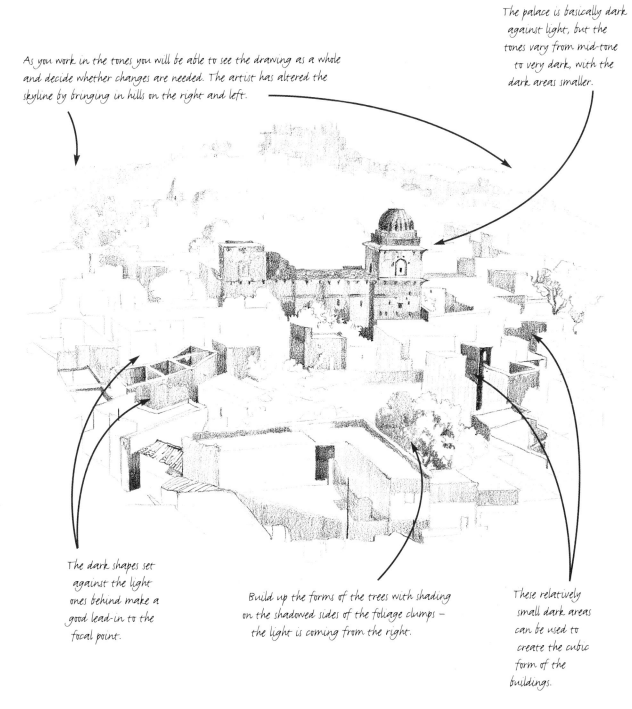

The dark shapes set against the light ones behind make a good lead-in to the focal point.

Build up the forms of the trees with shading on the shadowed sides of the foliage clumps – the light is coming from the right.

These relatively small dark areas can be used to create the cubic form of the buildings.

STAGE 5
BUILD UP TONE AND DETAIL

■ Now you can begin to add detail, suggesting the buildings on the hillside and drawing in a few doors and windows, especially in the foreground. Add small areas of dark tone, distributing them to form a balance, and sharpen up the line drawing in the foreground and middleground to bring these areas forward in space.

Strong contrasts of tone draw the eye to the focal point, so leave the trees and building as white paper to contrast with the dark shape behind.

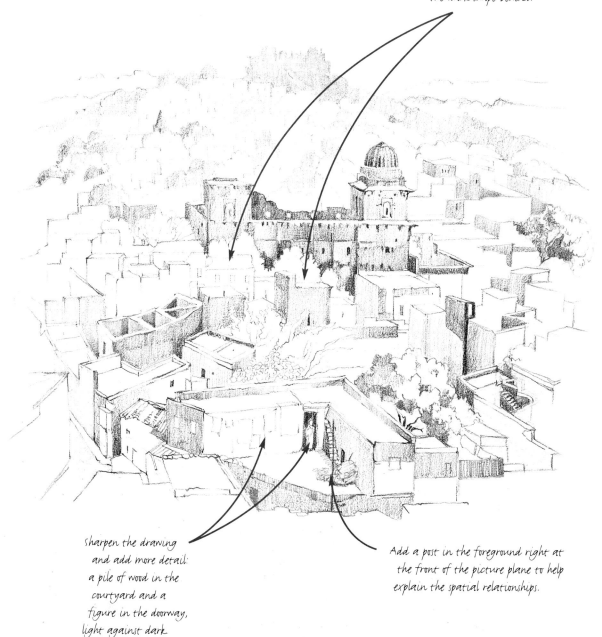

sharpen the drawing and add more detail: a pile of wood in the courtyard and a figure in the doorway, light against dark.

Add a post in the foreground right at the front of the picture plane to help explain the spatial relationships.

STAGE 6
GIVING A SENSE OF PLACE

■ Add as much extra detail as you want, from patterns on buildings and roofs to figures. Including people, and details such as clotheslines, adds atmosphere and brings in a narrative touch that builds up a more complete picture. In this case the two women in the foreground are also effective pictorially, strengthening the impression that we are looking out over the scene, just as they are.

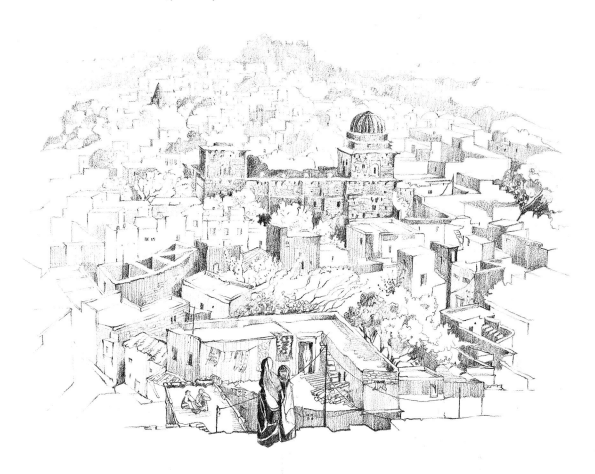

Touches of pattern and texture contrast with the stark cube shapes of the buildings. The skyline building has been softened.

Draw in more detail on the palace, giving an indication of the texture within the overall tone.

Figures sitting on the left, together with the one in the doorway, give a sense of scale to the building and provide a touch of human interest.

The post and wire separate the figures from the foreground building, establishing their position at the front of the picture plane.

The figures emphasise the distance between foreground and background, and the placing slightly left of centre provides a balance for the dark shape of the dome.

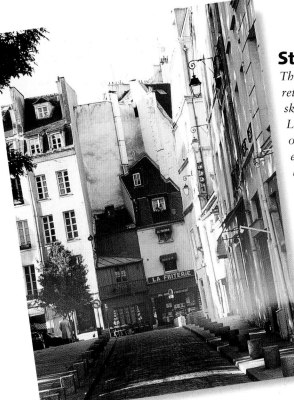

Street scene by Jim Woods

This is one of the artist's favourite subjects, to which he has returned several times, working from photographs and sketches. The initial attraction of this small street in Paris's Left Bank was the variety of roof lines, providing exciting shapes and angles, but when this sketch was done, the sunlight also played an important role, illuminating parts of the buildings and casting a deep shadow over the road and pavement. When you start a sketch, always take time to think about the effect you want to achieve. For example, would the subject look well as a monochrome drawing, or is the colour as important as the line? In this case, the artist decided on a loose watercolour sketch, worked on watercolour paper.

> **Practice points**
> - **ENSURING CORRECT PERSPECTIVE**
> - **MAKING A DETAILED DRAWING**
> - **CAPTURING LIGHT EFFECTS**
> - **APPLYING COLOUR LOOSELY**

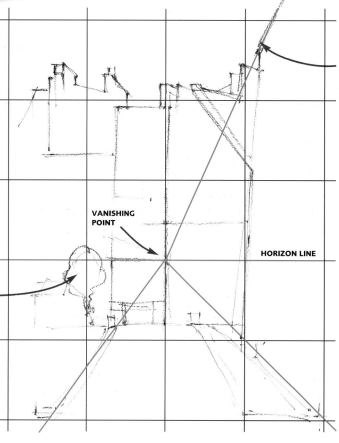

Make sure these angles are correct. You can check them by holding up your pencil at arm's length, turning it so that it corresponds with the line, then carefully bringing it down to the paper again.

The tree can be drawn quite loosely, but it is important to ensure that it is in correct proportion to the building. It just touches the bottom of the second-storey windows, which will provide a useful guide in the later drawing stages.

VANISHING POINT

HORIZON LINE

STAGE 1
THE FRAMEWORK

■ Start by marking the horizon line and vanishing point, to which all the receding horizontal lines will be related. The scene is viewed from the middle of the road, so the vanishing point is in the centre. Then use a 3B or 4B pencil to mark various salient points in the composition – for example, the top, middle and bottom of the central building, and the main points of the roofs. Check the proportions carefully as you go, noting important features such as the width of the buildings in relation to their height. This plotting stage is vital – if you begin drawing from the top you will almost certainly run out of paper before you reach the bottom.

STAGE 2
COMPLETE THE DRAWING

■ Continue to build up the drawing using a B pencil, keeping it well sharpened. Soft pencils smudge easily so, to make sure the paper remains clean, rest your drawing hand on a piece of white card – this can also double as a ruler when you need to draw true straight lines.

Check the proportions carefully as you draw. Don't just look at the shapes of the windows themselves; also look at the spaces between them and at the distance they are from the edges of the walls.

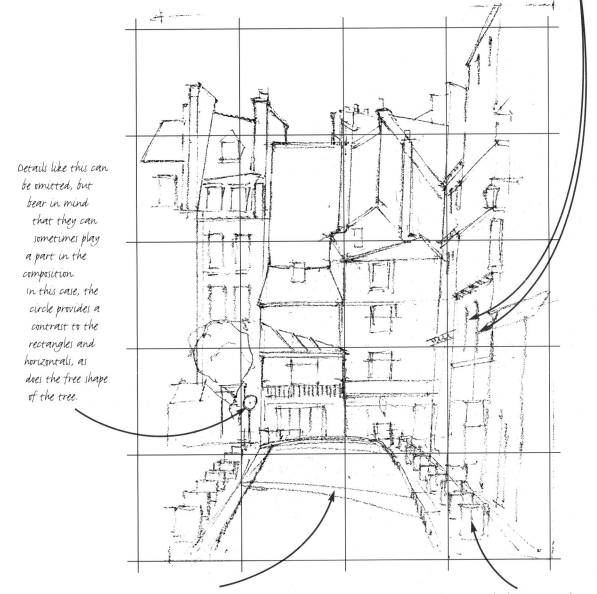

Details like this can be omitted, but bear in mind that they can sometimes play a part in the composition. In this case, the circle provides a contrast to the rectangles and horizontals, as does the free shape of the tree.

Mark in the strip of light in the middle of the shadow area. You will need this as a guide when you apply colour, and it is important to the composition as well to describe the slightly curved surface of the road and edge of the pavement.

Take care with the perspective here. Notice how the overlap between the bollards becomes progressively smaller as they recede from you.

STAGE 3
START PAINTING

■ Now lay on a light wash (a weak mix of raw sienna with a touch each of cadmium orange and light red), leaving small areas of white paper where the sunlight effect is brightest. Don't try to be too careful and avoid the temptation to 'fill in' the drawing. The looser the wash is the better, as this will counteract the tightness of the drawing and encourage a similarly broad effect in the later stages.

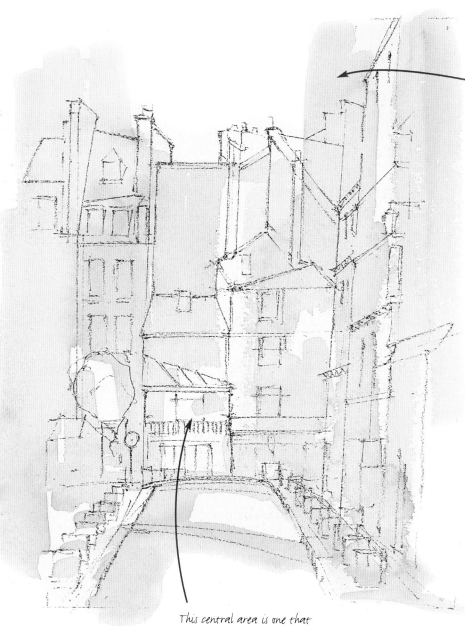

Use a flat brush and take the strokes downwards. Don't work over any of the strokes and don't worry if the effect doesn't look quite right, as you will be covering most of this wash with more colours later on.

This central area is one that must not be painted, as parts of it will be left to stand as highlights in the finished work.

STAGE 4
BUILD UP THE MID-TONES

■ Once the first wash is dry, introduce more colours in the light to middle tonal range, using various mixes of raw sienna and yellow ochre for the warm colours and combinations of indigo, Payne's grey and ultramarine blue for the cool greys, with touches of raw umber in places. Do not overpaint all of the first wash and, in the road area, lay blue-greys lightly over it so that the warmth shows through in places.

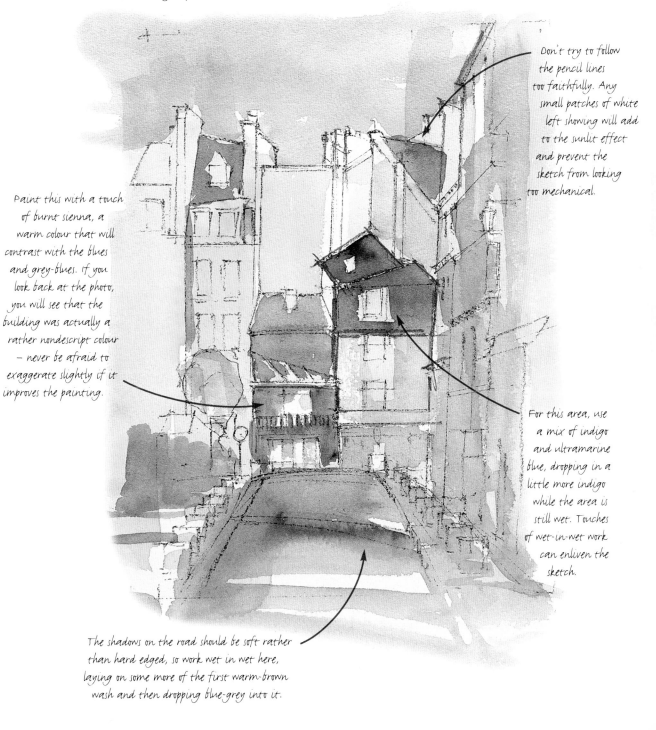

Don't try to follow the pencil lines too faithfully. Any small patches of white left showing will add to the sunlit effect and prevent the sketch from looking too mechanical.

Paint this with a touch of burnt sienna, a warm colour that will contrast with the blues and grey-blues. If you look back at the photo, you will see that the building was actually a rather nondescript colour – never be afraid to exaggerate slightly if it improves the painting.

For this area, use a mix of indigo and ultramarine blue, dropping in a little more indigo while the area is still wet. Touches of wet-in-wet work can enliven the sketch.

The shadows on the road should be soft rather than hard edged, so work wet in wet here, laying on some more of the first warm-brown wash and then dropping blue-grey into it.

STAGE 5
REASSESSMENT

■ At this stage in a painting it is helpful to put it away for an hour or two – possibly even a day – so that you can look at it with a fresh eye and decide if anything more needs to be done. You might decide to add extra definition with pens, pencils or coloured pencils. In this case, the artist has decided to build up the strength of the colours, using the same colour mixtures as in Stage 4, and then to add some drawing over the paint.

Make vertical lines with the pencil to reinforce this area and strengthen the vertical emphasis of the composition as a whole. Keep the lines well apart to allow the colour to show through and don't make them too uniform.

Emphasise the shape of the tree with curving lines and build up the form with diagonal hatching to suggest the area of shadow.

When all the washes are fully dry, use a 2B carbon pencil or 6B graphite pencil to make loose diagonal hatching lines over the paint. These help to draw the eye in towards the centre of the composition as well as provide extra foreground interest. Echo these diagonals on the roof and buttress, top right.

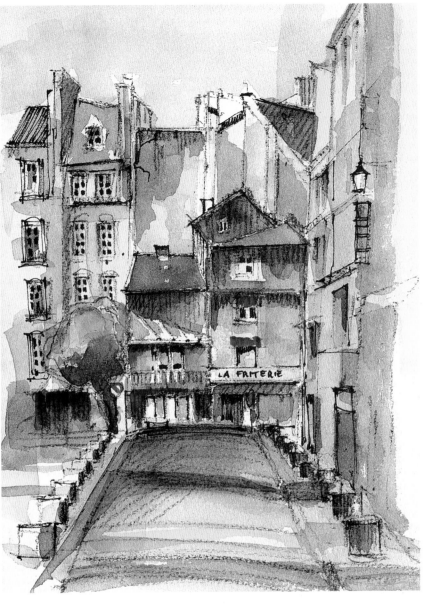

STAGE 6
EMPHASISE THE DARKS

■ The drawing carried out in the previous stage now needs to be balanced by more dark colours. Gradually begin to add deeper areas of shadow all over the painting, using the previous colours plus mixtures of burnt umber and ultramarine blue, and heighten the colour in places, especially on the tree, the foreground and the central building. For the traffic sign, use the same colour as for the shadow on the red-brown building, a mixture of cadmium red and a touch of burnt sienna. Pure red would stand out too much from the more muted surrounding colours.

The shadow on the central building makes an interesting shape that contrasts with the geometric shapes of the buildings themselves.

For the tree, dip the brush into an indigo and ultramarine blue mixture and then pick up some cadmium yellow with the tip so that the colours merge to make a warm green. This links with the buildings and foreground and contrasts with the blues and greys. Don't fill in this area too precisely – remember that you are aiming at a sketchy effect.

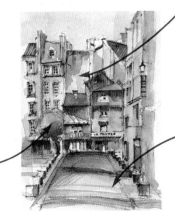

This band of yellow ochre enlivens the foreground and provides a link between this area and the warm yellows of the buildings.

THE FUNDAMENTALS

Composition

However well you can draw, your drawings and paintings will not succeed completely unless you think about how to compose them. A sketch with a dominant feature placed right in the middle is usually very dull, failing to engage the viewer's attention. Always try to create a rhythm in the composition that leads the eye into and around the picture, and create interest by varying shapes and balancing tones.

Choosing your viewpoint *The angle you look at a scene will alter the perspective and skyline.*

Preliminary decisions

When you are sketching outdoors, you can move around to choose the best viewpoint, which is the first step in deciding on the composition. Using a viewfinder (a piece of cardboard with a rectangular hole cut in it) is very helpful in making these first decisions, and you can hold it up at different distances from your eye to experiment with different skylines, more sky or more foreground. If you have time to visit the scene more than once before sketching, choose different times of day, as you may find that a different light source, perhaps with more dramatic shadows, improves the composition.

Landscape or portrait? *Use your viewfinder to discover which format has more impact.*

Composing the picture

Although there are no set rules for composition, there are some useful tips. The focal point in a landscape is usually placed in the middle distance, but

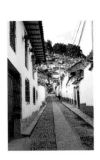

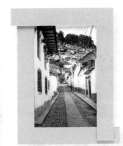
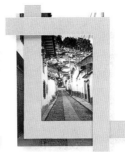
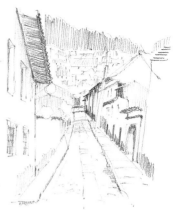

avoid putting it right in the centre of the picture, and think of ways to lead the eye towards it. These could be the diagonal lines of a foreground field or a path curving in from the foreground. Also, make the contrasts of tone or colour strongest at the centre of interest, as this automatically draws the eye. Don't concentrate all the attention on this focal point, leaving dull areas elsewhere where nothing is happening. However, bear in mind that cropping the design around a centre of interest can often be effective, especially when working from photographs.

Vary the shapes, contrasting squares or rectangles with round shapes and curves, and don't repeat exactly the same shape in any one area. Distant trees, for example, may appear as little more than rounded blobs, but they are not all uniform. If the composition is mainly horizontal, as in a landscape with fields, putting in a vertical object such as a tree or fence post may help to hold it together.

Using a viewfinder
Experiment with a viewfinder to find the most interesting scene to sketch. Sometimes cropping into a view can make the image more interesting.

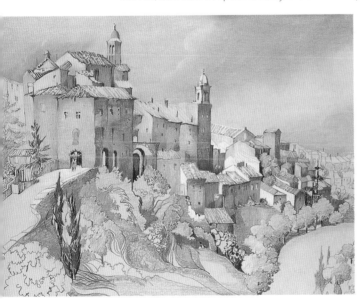

Rustic hilltown
The composition of this group of buildings and trees is excellent, drawing the eye through the sketch into the distance.

Working from photographs

If using reference photos, beware of copying them exactly; any number of details can be altered to make a good composition without detracting from the original subject matter. For example, the sky or the foliage can be changed to suggest different weather or time of day; you can alter the light source, bringing in shadows and stronger tonal contrasts; and you can omit unhelpful features and make more of others. Don't automatically stick to the same format, either. You might make an upright composition from a horizontal photograph by leaving out dull areas at the sides or by increasing the foreground and sky. Think of the photograph as a starting point for the ultimate aim of making the picture work.

EXERCISE 11

Colonial mansion
by Catherine Brennand

When approaching a complex subject, it is often a good idea to select only part of it, using a viewfinder to help you make a selection. You can sometimes improve your composition by focusing in on one section. If you are working from a photograph, don't automatically stick to the same format. In this case the portrait format emphasises the upward thrust of the columns in the centre and cuts out some of the less interesting features of the building, allowing the artist to concentrate on its most distinctive and significant features.

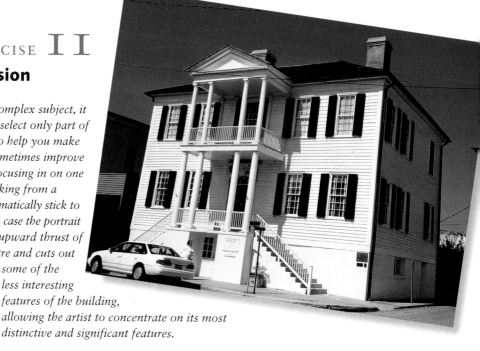

Practice points
- **SELECTING THE BEST AREA**
- **SQUARING UP**
- **PAINTING WITH TWO COLOURS**

STAGE 1
THE FRAMEWORK

■ Working from a photograph, as the artist has done here, has one major advantage, as it allows you to make a squared-up drawing (as explained on pages 10–11). This ensures that the proportions will be correct from the outset, and you will not have the frustration of discovering errors when you reach the painting stage.

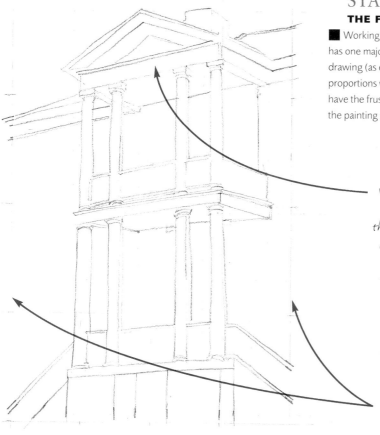

When you have blocked in the main elements with an HB pencil, you can erase the grid lines. Once the columns, roof and balconies are in place, it is relatively easy to fit the rest of the facade around them.

Draw the grid of squares with an H pencil, then transfer the information carefully from the photograph to the painting surface. Don't be concerned with small details at this stage.

STAGE 2
THE FRAMEWORK

■ You will find it helpful to use the lines of the slatted wood cladding to help position the windows and shutters reasonably accurately. Although this is not an exercise in precision, it is wise to be careful in this stage of the drawing, as it forms the skeleton of the painting to come.

Watch the perspective here, noting that the columns are well above eye level, so that their tops form a pronounced curve and you can see the undersides of the capitals.

Aim to give an impression of the balconies without being too precise and don't worry if some of the lines wander off the vertical slightly.

Before you draw the shutters and windowpanes, count how many of each fit into the main rectangles, and then sketch them in lightly, using an eraser if you make a mistake.

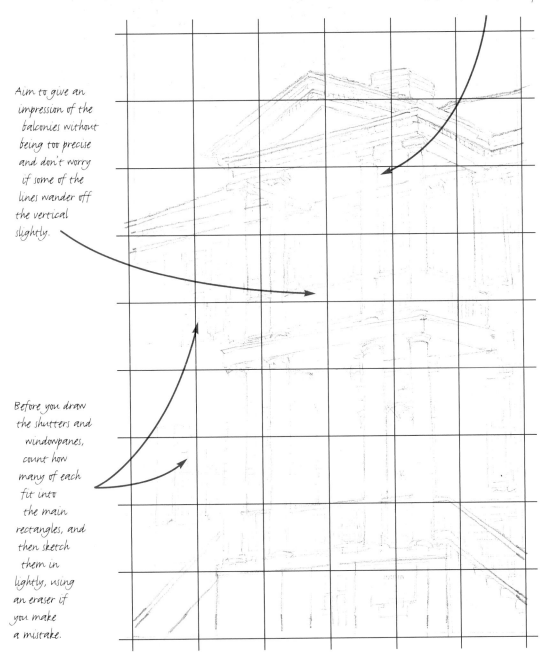

STAGE 3
LAY THE FIRST WASHES

■ This is essentially a monochrome subject, but rather than producing greys by watering down black paint or ink, which can dull the paper, the artist is using two watercolour shades. These are Prussian blue, a strong staining colour containing a significant amount of green, and burnt umber, an earthy, gritty brown with a lot of red in it. Together, in different proportions and with varying amounts of water, these two colours can produce a huge range of the subtle shades that artists describe as coloured greys.

Let the wash for the sky dry before putting on a slightly darker mixture of the same colours for the roof.

To define the main shapes and shadows, lay a thin wash of Prussian blue with a little burnt umber added to mute the colour slightly.

Begin to indicate the tonal pattern by varying the strength of the washes, but don't make them too dark.

STAGE 4
BUILDING UP COLOURS AND TONES
■ The painting is to be built up in layers, like any watercolour, so you can move towards mid- and dark tones at this stage, strengthening the tones and colours, and ensuring that each wash is dry before the next is added.

For the chimney and roof, lay thin washes of burnt umber alone. Notice how this red-brown makes the sky appear much bluer by contrast.

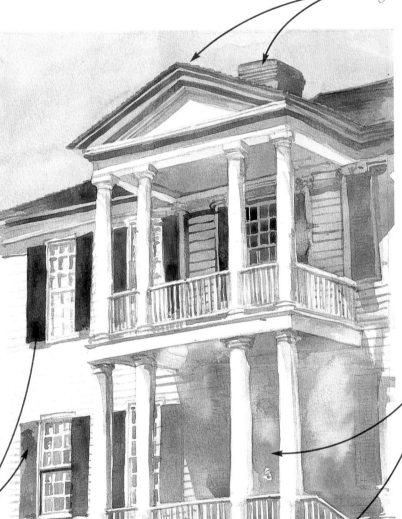

Add a little more of each colour to the wash and strengthen the shadows under the balconies and eaves. Use the same wash for the shutters and, when it's dry, add another layer, continuing until you've achieved the depth of colour you want.

Vary the tones on the shutters to give extra interest to the painting. Those on the lower level have two layers, while the upper ones have three.

MUSEUM

STAGE 5
ADD TEXTURE

■ It is often tempting to paint buildings too precisely and meticulously, ending up with a rather sterile result, so the artist has decided to exaggerate the wood and stone textures of the building itself. She has also added some surface texture to make the sketch look less tidy and to give it more life and movement. For this, she has used a wax-resist method combined with a lino-printing roller.

Define the small details with a drawing pen and black ink, or with a felt-tip pen. You could use a small brush, but there is a danger of brush lines becoming tight and overworked; the pen will allow you to draw freely.

Paint the wooden boards in varying mixtures of Prussian blue and burnt umber and use a very dark tone, with more blue, for the central door to ensure that the columns stand out well.

Use a sharpened wax candle to scribble over the balustrades, architraves and capitals, concentrating most wax on the sunlit sides. Then dip a lino-printing roller into a mid-toned wash and take it over the whole picture. The colour will slide off the waxed areas, leaving slightly mottled white highlights. You might like to practise this technique on a spare piece of paper first, as wax cannot easily be removed if you make a mistake.

The wax-resist method can be done by simply laying washes over the wax with a brush, but the roller creates more interesting textures, as the paint gathers in small pools and splashes in places.

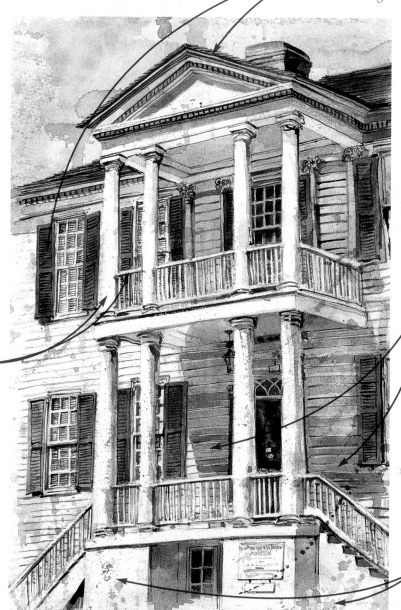

Use a drawing pen with black ink—or even a felt tip pen—to hatch shadows onto the overhang under the roof, onto the decorative eave above the porch, and behind the shutters.

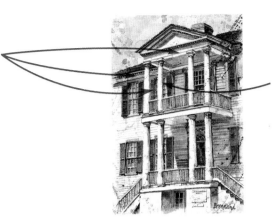

Hatch shadows onto the right side of the pillars to accentuate the three-dimensional nature of the architecture.

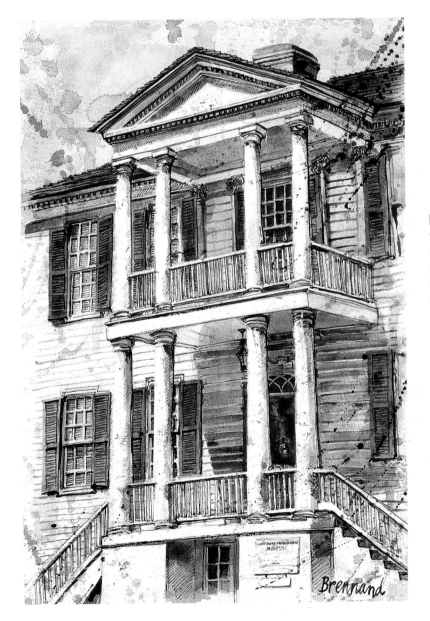

STAGE 6
FINAL TOUCHES

■ Add the final touches of detail to your sketch, making sure you do not overwork it. The spatterings of watercolour paint and the scratchy hatched shadows add life and texture to the building.

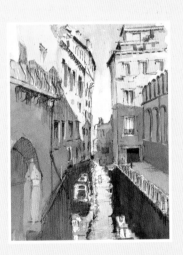

Focus on Buildings

Once you have mastered the
fundamentals, you may wish to
concentrate on those subject areas that
are specific to buildings, for example
Architectural Detail or Reflections.
Simple step-by-step exercises show how
to perfect those details that will set your
sketch apart.

FOCUS ON BUILDINGS

Architectural detail

You don't need an architectural background to become proficient at drawing buildings as long as you can train yourself to observe with care. You may not be able to tell a Victorian church or cathedral from a Gothic one, but you can certainly see that both of these look quite different from a Georgian town house or a timber farmhouse.

Building styles

Buildings derive much of their special character from the materials used in their construction, which vary from area to area according to local resources. If you want to give a sense of place in your sketches, look for these differences. You may see red-tiled roofs in one part of the world and stone or slate in others, and the shapes of the individual tiles or stones may also vary.

The walls may be made of brick, stone or wooden clapboard – or of course concrete – but even buildings that share a common material will not be constructed in the same way, as styles alter from period to period. Look for details that suggest a particular age or are typical of a place, such as decorative ridge tiles or patterns on the walls or, in the case of stone buildings, the thickness of the walls. If there are interesting textures, such as crumbly old brick or uneven whitewashed walls, think of how to convey these in your sketches. If you are drawing brickwork, look carefully to see how the bricks are laid, and remember there is mortar in between them. Don't try to draw in every brick; you can usually suggest them with a few carefully placed here and there.

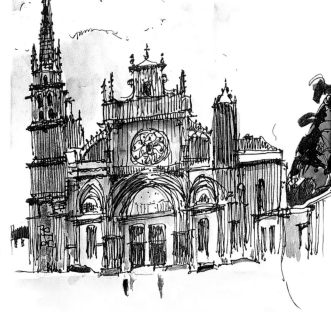

Carved cathedral
The lively lines and wash of this sketch illustrate how detail can be included in a piece without losing spontaneity.

Wood and water
It didn't take the artist long to sketch this old mill using sepia ink and white chalk on tinted paper. The timber walls and solid structure fit into the surrounding scenery.

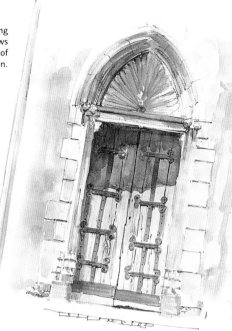

The strong shadow shows the direction of the sun.

Note the sun-bleached wood and rusty hinges.

Siesta *The crumbling, textured screens and railings conjure up a hot afternoon in a backstreet town.*

Windows and doors

The sizes and proportions of doors and windows, and the way they are arranged, give important clues as to the age and function of the building. Grand houses, whether in town or country, tend to have large, tall windows, indicating spacious rooms and a comfortable lifestyle, whereas in humble dwellings the windows are often small and set far apart to occupy much less wall space. In old stone cottages, the walls are sometimes very thick with the windows set well back.

Doors also vary a great deal. Theoretically, a door should be tall enough for an average person to enter without stooping, but some are actually uncomfortably low, while others are much taller than needed in order to create an impression of grandeur.

Observe all these proportions carefully as you draw, and don't make the common mistake of making doors and windows either so small or so large that the construction of the rooms behind them appears impossible. If you can visualise the general structure of a building, you can avoid errors that you may not notice but that might be obvious to anyone with a knowledge of the building.

Blue door
Photographs are a wonderful reference tool if you wish to include architectural detail in your sketch.

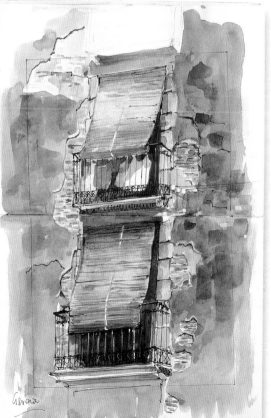

Use a thin brush for delicate iron railings.

Accentuate the crumbling plaster.

Add texture to the blinds.

Girona

EXERCISE 12

Leaning tower by David Arbus

The Leaning Tower of Pisa must be one of the most famous buildings in the world, not only because of its worrying departure from the vertical but also because of its beauty. Built in the late twelfth century, it forms part of a marvellous complex of ecclesiastical buildings that attracts hordes of tourists, students and artists every year. As a subject for a sketch, it is more challenging than many others; the elegant, regular arches need to be drawn with great care, and because of the angle of the tower it is not possible to rule vertical lines for the sides, as you can with other buildings. The artist has decided to focus on just one part of the tower for this pencil drawing, setting it against the verticals of the building on the left to give stability to the composition.

> **Practice points**
> - ESTIMATING SPACING AND ANGLES
> - VARYING THE PENCIL SHADING
> - LOOKING FOR PERSPECTIVE EFFECTS
> - DECIDING WHEN TO STOP

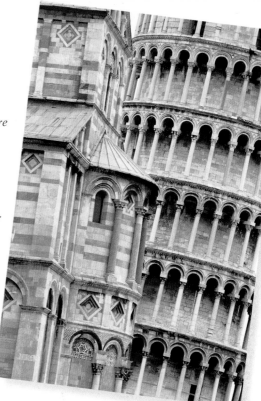

STAGE 1

ESTABLISH THE MAIN ELEMENTS

■ Using an HB pencil, place the two main elements – the vertical building on the left and the flattened-out curves of the tower, which are almost horizontal. Make sure that the spacing and angles of these are correct, or you will have problems later when drawing in the arches.

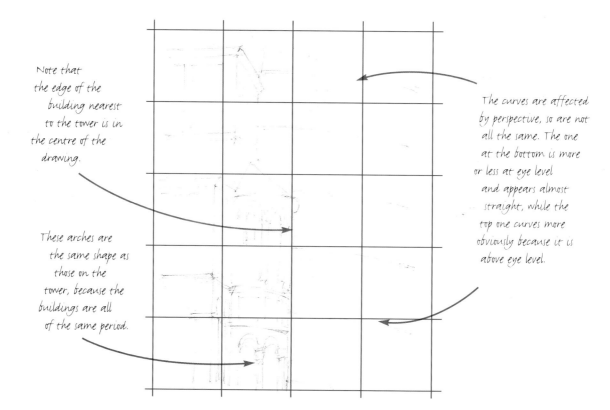

Note that the edge of the building nearest to the tower is in the centre of the drawing.

These arches are the same shape as those on the tower, because the buildings are all of the same period.

The curves are affected by perspective, so are not all the same. The one at the bottom is more or less at eye level and appears almost straight, while the top one curves more obviously because it is above eye level.

STAGE 2
BUILD UP THE DETAIL

■ Repetition and symmetry can cause problems for the artist, as it can become very boring to draw the same shape over and over again, and boredom can cause you to lose your way or to become careless. The best way to cope with this is to move from one area of the drawing to another rather than trying to draw all the repetitive shapes in one step.

To give yourself a rest from the arches, start to draw the pattern on the vertical building. This is an important part of the sketch, as it is typical of the style and period of the building's construction.

Mark in these decorative details as simple diamond shapes at this stage. Once you have established the overall shapes and their proportions in relation to the wall, you can build up the forms later.

Draw the middle row of arches first to set the spacing, which can then be followed upwards and downwards in the next stage.

STAGE 3
LINE AND SHADE

■ Now switch to softer pencils – a 2B and a 4B – and complete the building on the left. Working from left to right helps to avoid smudging the drawing, which is easily done. Obviously, if you are left-handed you will need to reverse the procedure.

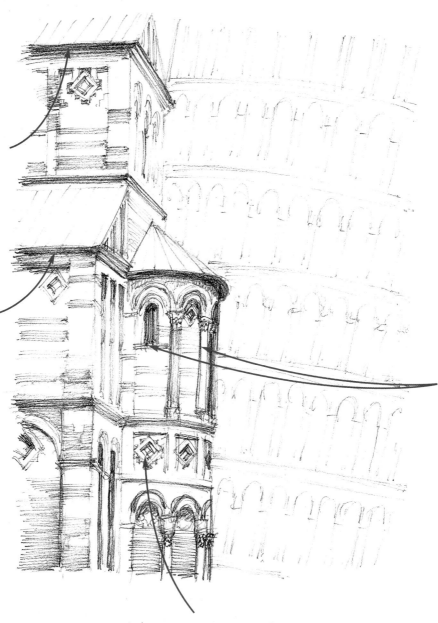

Use horizontal lines of shading under the roofs and for the bands of pattern. Stressing the horizontals and verticals of this building helps to anchor the leaning tower.

Vary the shading and the pencil lines in these areas to give the drawing more interest.

You don't have to treat every part of the drawing with the same degree of finish. The lower of these two shapes can be left just lightly sketched in.

STAGE 4
FINALISE THE DRAWING

■ With the left-hand building complete, it is easier to judge how much strength of tone is needed for the arches and whether or not to include all of them. The artist has decided to leave the sketch at this stage, with only three rows of arches filled in and the others left to the imagination – a good example of 'making less say more'.

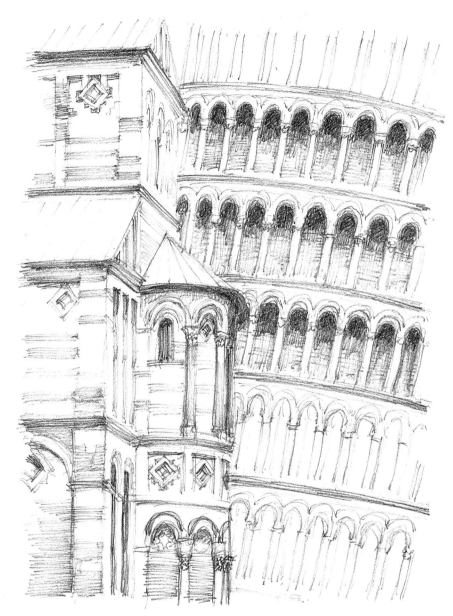

Start by drawing lightly with the HB pencil, making loose vertical lines crossed with horizontals (cross-hatching); then use the 2B pencil to shade more heavily at the tops of the arches, where the shadow is deep.

The completed three rows of arches, contained by the curves that make shallow near-diagonals, form a strong shape that balances that of the left-hand building. If all the arches were filled in, this shape would be lost, reducing the impact of the drawing.

Street signs by Jane Hughes

Architectural subjects are often concerned less with the shapes, sizes and proportions of the buildings themselves than with the wealth of exciting detail, from chimneys and drainpipes to door handles. These details, whether simple or exotic, decorative or functional, are the touches that complete the architecture and give it individuality. In a view like this, the buildings take a back seat; it is the colourful signs that draw the eye and create the busy atmosphere of the city. At first sight, this street scene might seem rather a daunting subject to draw, but the bold shapes and bright colours make it an irresistible one. To get the best out of the subject, the artist has decided to work in coloured pencils, which can be used with considerable precision and can also achieve rich, solid colours.

Practice points

- **USING COLOURED PENCILS**
- **VIEWPOINTS AND PERSPECTIVE**
- **MAKING GRID LINES**
- **DECIDING WHAT TO EMPHASISE AND WHAT TO OMIT**

Start by lightly drawing this edge of the largest of the signs, which will be the anchoring point for the drawing. If you check this against the vertical side of the frame you will notice that it is not quite perpendicular.

Draw up your frame and a guideline grid using a pencil. Draw diagonals from corner to corner to find the centre of the frame; use a ruler if it helps.

Using the grid lines and measuring carefully, draw the supporting rails; notice how this sign projects forwards out of the frame.

Mark in the vertical and horizontal centre lines. You can add more grid lines in the same way wherever they might be helpful, particularly in the lower half of the picture.

STAGE 1

THE FRAMEWORK

■ With such a complex image, it is a good plan to find some dominant feature to serve as an anchor for your drawing. You will also find it helpful to draw a frame, which you can mark in very lightly, using a pale, neutral-coloured pencil or even an ordinary soft graphite pencil. This can be worked into the sketch later or can be erased if you prefer. The strong shapes of the signs and the rails that support them help with plotting the drawing on the page.

Draw in the rest of the supporting rail below the sign.

STAGE 2
BUILD ON THE FRAMEWORK

■ The mass of signs and the different angles make it hard to understand the perspective. Because the viewpoint is quite low, the vertical lines appear to converge towards the top of the frame, while the horizontals drop away to either side of the centre line. It is important to try to show how the signs hang in different and interlocking planes.

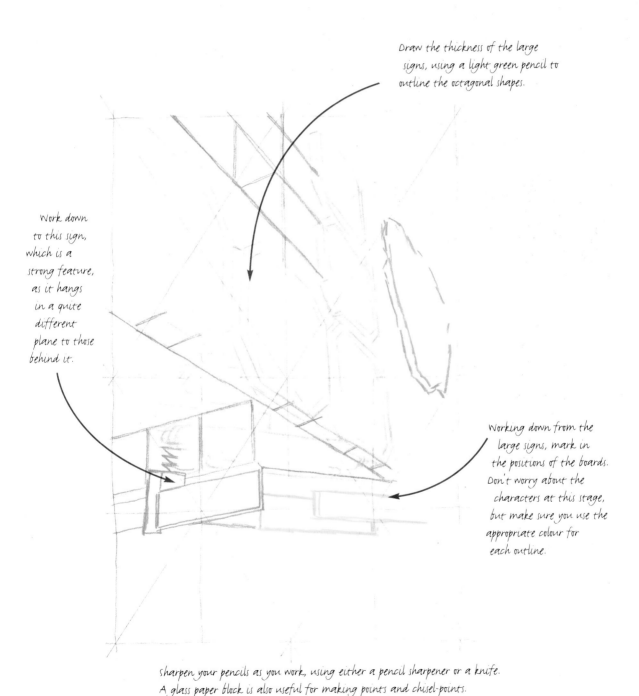

Draw the thickness of the large signs, using a light green pencil to outline the octagonal shapes.

Work down to this sign, which is a strong feature, as it hangs in a quite different plane to those behind it.

Working down from the large signs, mark in the positions of the boards. Don't worry about the characters at this stage, but make sure you use the appropriate colour for each outline.

sharpen your pencils as you work, using either a pencil sharpener or a knife. A glass paper block is also useful for making points and chisel-points.

STAGE 3
ADDING AND OMITTING

■ Don't think of the frame as a rigid constraint. Here the signboards are extended to make complete shapes, giving the sketch an irregular, more lively outline. Where the signs are layered over each other, clarify the outlines of each with the appropriate colour. Once the majority of the signboards are in place, you can see what else is left to include and what you might leave out.

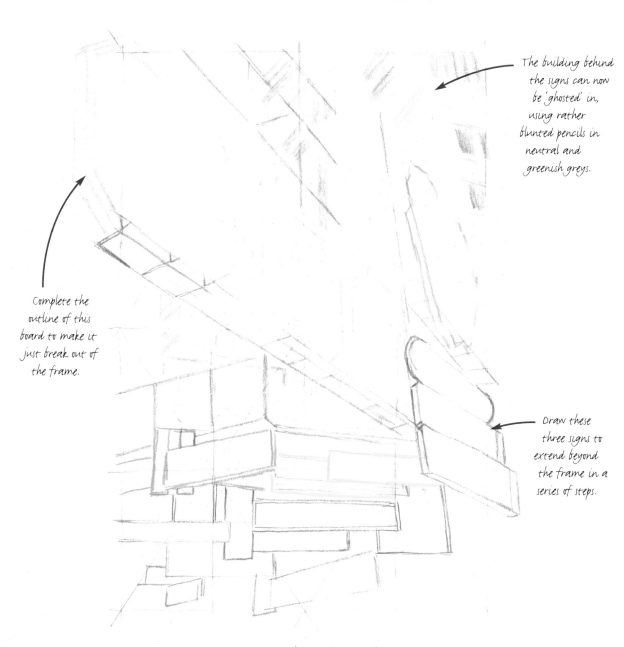

The building behind
the signs can now
be 'ghosted' in,
using rather
blunted pencils in
neutral and
greenish greys.

Complete the
outline of this
board to make it
just break out of
the frame.

Draw these
three signs to
extend beyond
the frame in a
series of steps.

You can now erase some of the grid lines. A white plastic eraser
works best. Use a scalpel with a sharp, curved blade to scrape
away unwanted marks.

STAGE 4
DEVELOP THE DETAILS

■ Having positioned all the signs, you can now start on the characters. Although in reality they are quite precisely drawn, for the purposes of the sketch, freshness and brightness are more important than slavish accuracy. However, pay attention to perspective – note, for example, that you can see more of the black on the left of the largest sign than on the right. Work from light to dark, so that you can build up the depth of colour gradually, and to prevent smudging, rest your hand on a sheet of paper laid over the completed work.

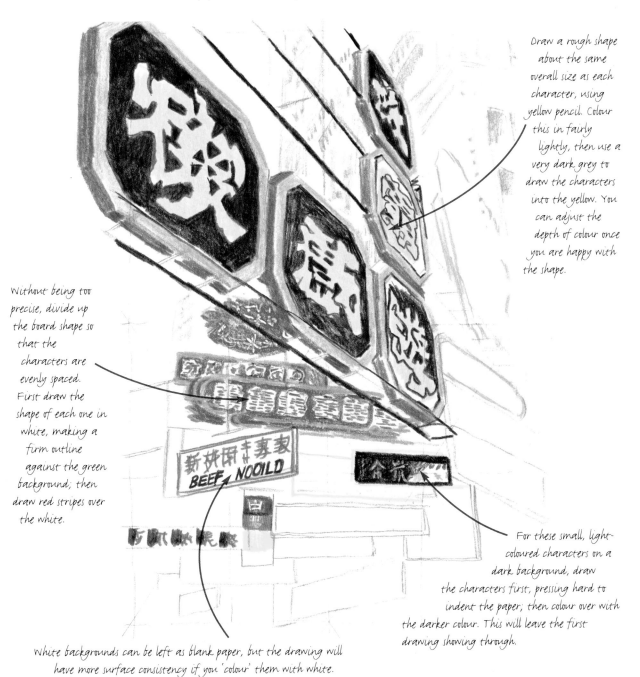

Draw a rough shape about the same overall size as each character, using yellow pencil. Colour this in fairly lightly, then use a very dark grey to draw the characters into the yellow. You can adjust the depth of colour once you are happy with the shape.

Without being too precise, divide up the board shape so that the characters are evenly spaced. First draw the shape of each one in white, making a firm outline against the green background; then draw red stripes over the white.

For these small, light-coloured characters on a dark background, draw the characters first, pressing hard to indent the paper; then colour over with the darker colour. This will leave the first drawing showing through.

White backgrounds can be left as blank paper, but the drawing will have more surface consistency if you 'colour' them with white.

STAGE 5
ADD TONE

■ Coloured pencils allow you to achieve a comprehensive range of tones from the richest black-violet to the faintest whisper of white. Colours can be blended and rubbed together, overlaid and cross-hatched. Water-soluble pencils can be used dry, then moistened with a brush to produce wash effects. Highlights can be lifted out with an eraser or scraped out with a scalpel and boosted with white.

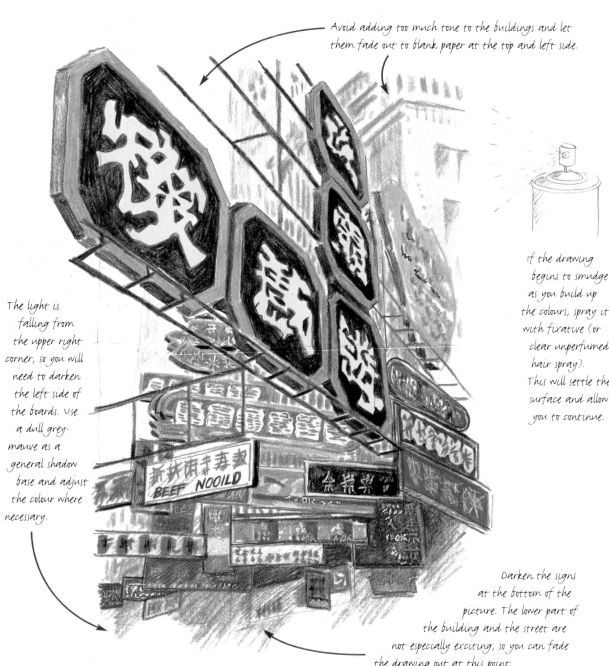

Avoid adding too much tone to the buildings and let them fade out to blank paper at the top and left side.

The light is falling from the upper right corner, so you will need to darken the left side of the boards. Use a dull grey-mauve as a general shadow base and adjust the colour where necessary.

If the drawing begins to smudge as you build up the colours, spray it with fixative (or clear unperfumed hair spray). This will settle the surface and allow you to continue.

BEEF NOOILD

Darken the signs at the bottom of the picture. The lower part of the building and the street are not especially exciting, so you can fade the drawing out at this point.

STAGE 6
FINAL ADJUSTMENTS

■ Now you can assess the sketch and decide whether anything needs tweaking. The pencils have been used quite firmly, so there is little directional pencil texture showing, except on the very softly shaded buildings. The stars of the drawing are the signboards and their striking characters.

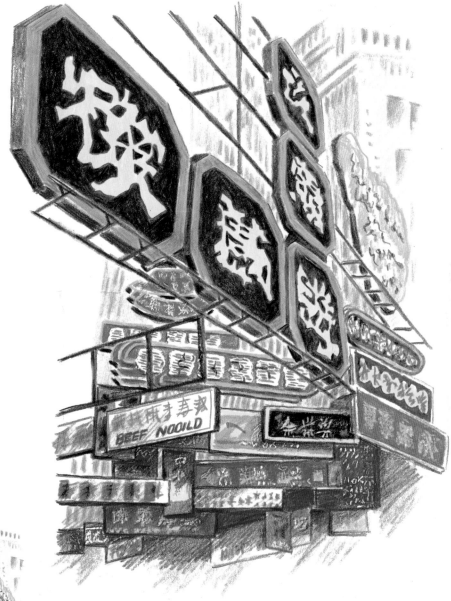

Erase any of the frame and grid lines that have not been covered up.

Even out any patchy areas around the characters.

Emphasise the lower edges of the signboards to separate them clearly from each other.

Boost the shadows below these shapes and pick out the inner edges with the background green.

EXERCISE I4

Southern grandeur
by Jim Woods

The colonial architecture in Charleston is justly famous and is a great tourist attraction as well as a constant source of inspiration to artists. The classic

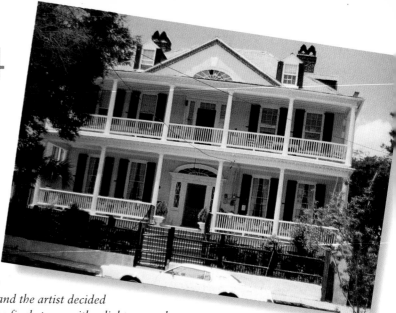

proportions, delicate veranda rails, tall shuttered windows and elegant detailing over the main door invite a linear treatment, and the artist decided to make a pen drawing, softening it in the final stages with a light monochrome wash. He has worked on watercolour paper, which breaks up the pen line slightly to provide a pleasing texture. This paper also holds the wash well; on a smoother surface such as drawing paper, washes tend to slide around and form puddles.

Practice points
- MAKING A 'PORTRAIT' OF A HOUSE
- ACHIEVING CORRECT PROPORTIONS
- BUILDING UP DETAIL
- DRAWING WITH A PEN

STAGE I

THE FRAMEWORK

■ The house is made up of a series of simple shapes – mainly near-squares and rectangles offset by the triangle of the roof. Draw these main lines in first, taking great care with the proportions of each rectangular shape and ensuring that they are all of equal size. If you get the proportions wrong at this stage you will find you have to distort the shapes of windows and other details in order to fit them in. Start with a light pencil drawing, and when you are sure the lines are correct, draw over them with a fine-tipped black pen, water-soluble if possible, then erase the pencil lines.

Check the width of spaces, such as that between the two verandas, by holding up a pencil at arm's length and moving your thumb along it. If you prefer, you can use a ruler to take actual measurements; a small plastic ruler is a useful addition to the drawing kit.

You need not draw the front line of the overhang at this stage, but mark in the angle where the edge of the roof recedes. Luckily there is very little perspective to worry about in this subject, because it is seen almost directly from the front.

Notice that the ground floor of the house is taller than the first storey, making the rectangles deeper than those above, which are almost square.

STAGE 2
ADD DETAIL

■ Now that you have the framework in place, it is relatively easy to fill in windows, doors and so on, as each has its own place within the rectangles. Drawing a house portrait is very much like drawing a person, where you establish the main shape of the head before placing the eyes, nose and mouth. Look carefully as you draw, checking proportions with care, and if you feel you may need to erase from time to time, draw in pencil first, as before.

Be on the lookout for the unexpected. You might think that the top fanlight would be in the centre of the two veranda supports, but in fact it is not, because the house is viewed at a very slight angle.

Draw in these shapes loosely. They will be important in the next stages, because they form areas of dark tone that will help the small white dormer windows to stand out.

Don't be too precise about achieving straight lines; a little crookedness here and there will give character to your drawing. But do make sure you draw the right number of spokes in the fanlights over the door – count them first and place them by making small marks around the semi-circle.

STAGE 3
BUILD UP THE TONES

■ Continue to define the details and build up the darker tones, which will throw the whites of the verandas and balustrades into relief. Try to vary the pen lines, both to give extra punch to the drawing and to describe the various features.

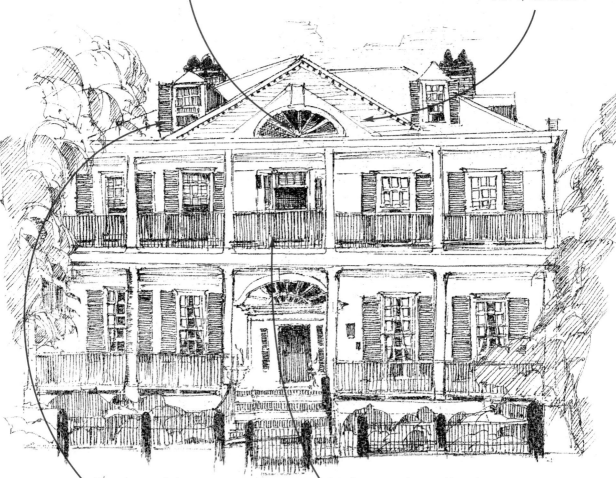

The patterning beneath the roof edge gives emphasis to this area, helps to build up a complete portrait of the house and acts as a pictorial balance to the wealth of detail below.

To vary the tones, use diagonal cross-hatching for the panes on the left and fill in the central ones with almost solid black.

These dormer windows are an attractive feature of the house, so make them stand out by making dark hatching strokes around the structures and on the windowpanes.

Make a series of vertical lines here to suggest the railings. Try to space the lines fairly evenly, but don't be too precise or the drawing may look overly mechanical.

STAGE 4
ADD THE WASH

■ The beauty of using a water-soluble pen is that you can wash over it with water to make the ink run, thus providing areas of grey. This is what the artist has done here, but if you have used a permanent pen to create your sketch, you can achieve the same effect by mixing up a weak wash of lamp black or dark grey or black Indian ink diluted with (preferably) distilled water. This is because ordinary black ink usually shows a shade of red-brown when diluted with water.

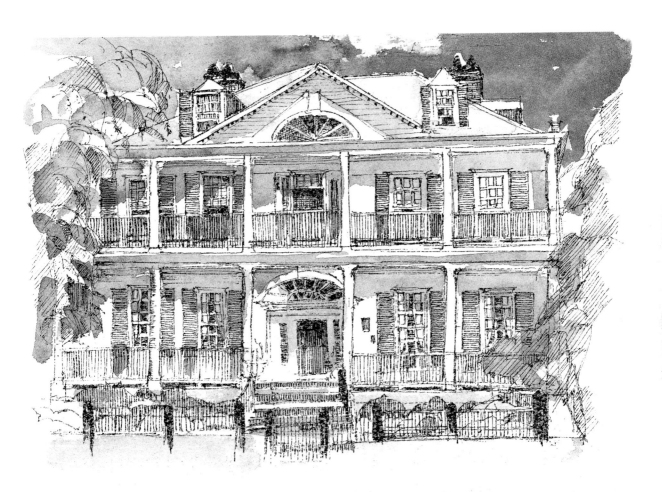

Add a soft shadow beneath the roof, leaving the area around the fanlight white to suggest sunlight.

Wash over the darker parts of the door to make a light shadow on the right, leaving the top of the arch and the left side as white paper.

Using a medium-sized round brush, wash very lightly over the hatching lines to soften them and deepen the tone.

Make fairly random washes on the tree, curving the brush marks to give the impression of foliage.

EXERCISE 15

Derelict kiosk by Jim Woods

Sketching is usually an on-the-spot activity, but sometimes one finds an appealing subject that for various reasons will have to be worked from a photograph, and this is one example. It shows one of the broken-down kiosks that used to grace Brighton's West Pier, which was built in 1866 and once thought of as the finest in England. Sadly, it was badly damaged after World War II and deteriorated to the extent that it had to be closed in 1975. The artist was invited to view it, and since there was no chance of making even a rapid sketch, he took a number of photographs as reference for paintings. The danger of working from photographs is that the painting may become too detailed and static, but he has skillfully contrived to convey a sketch-like quality to his work by working freely and knowing when to stop – overworking can quickly sacrifice the feeling of spontaneity.

Practice points

- **MAKING A 'PORTRAIT' OF A HOUSE**
- **ACHIEVING CORRECT PROPORTIONS**
- **BUILDING UP DETAIL**
- **DRAWING WITH A PEN**

STAGE 1

THE FRAMEWORK

■ Begin by thinking about how the sketch will sit on the paper so that it makes a good composition. In the photograph, the kiosk occupies too much of the picture space, so the artist decided to invent a foreground, with a shadow, to push the building back in space. Plot the outline of the building, using a 3B or 4B pencil, looking for the main shape and the basic proportions only at this stage and avoiding any detail.

Draw the centre line, then measure carefully to each of the other verticals, including the outer edges.

If you are not confident about getting these small protruding shapes in the right place at this stage, leave them until you have drawn in the horizontals.

Note that the top of the building forms a gentle curve, sloping more sharply at the outer edges.

To assess the overall shape of the structure without getting seduced by details, try half-closing your eyes. Then check the width-to-height ratio by using the pencil-and-thumb method.

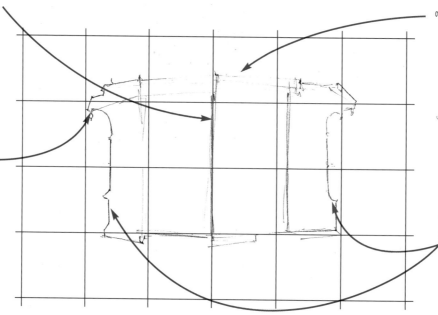

STAGE 2
DEVELOP THE DRAWING

■ Draw the arches and windows of each main section separately to ensure that the proportions are correct. You need not be too precise, as any small errors will help to convey the semi-collapsing state of the building. The subject is quite complicated and full of the exciting decorative details beloved of Victorian architects, but these must be ignored at this stage or the painting may become too 'busy'.

When you draw the arches, look for the 'negative' shapes above them on the right and left. This is a good way of checking the drawing; if these shapes look wrong, it means you have drawn the curve incorrectly.

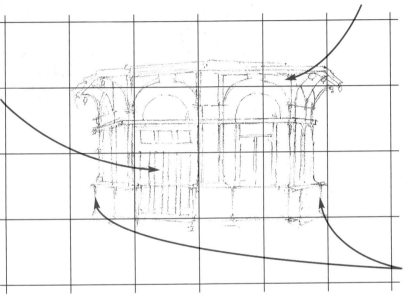

Make sure the proportions of the panes and the spaces between them are correct. You may find it helpful to mark them off along the top before drawing in the verticals.

The building is seen from almost directly in front, with the eye level below the centre, so the horizontals at the sides slope down slightly to the horizon line (eye level).

STAGE 3
ADD COLOUR

■ The drawing needs a little more work before colour is added, so mark in the window bars lightly, add definition around the tops of the arches and shade lightly over the darker areas. Then begin to lay on loose splashes of colour, reserving any highlight areas as white paper.

Start with diluted raw sienna and then switch to a mixture of indigo and viridian. Be careful with the indigo, as it is a very strong colour and needs a good deal of water to pale it.

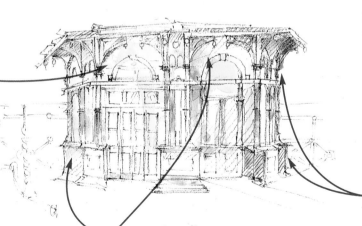

Burnt sienna can be used more strongly here. Don't try to 'fill in' the shapes too accurately; instead use a well-loaded large brush to make loose marks and don't worry if the paint slops over the edges.

The colours of the building had faded and rusted from the original vivid hues to subtle blends of green and warm browns. Use raw sienna both alone and in mixtures with burnt sienna, introducing touches of viridian above the arch.

STAGE 4
BUILD UP THE TONES

■ Continue to build up the colours of the building, using the same colours and mixtures as before but with less water. You can add some really dark tones at this stage, but if you have not used masking fluid, take care not to paint over the highlights. When you have completed the kiosk to your satisfaction, paint in the foreground shadow with a well-diluted mix of burnt sienna and ultramarine.

Notice how the highlights shine out as dark colours are painted around them.

The remains of the signboard make a good focal point for the picture. For the lettering, use burnt sienna with a little cadmium red and echo this bright colour by introducing red here and there among the browns.

Don't be afraid to make these shadows really dark; they will appear lighter when the sea and sky are added. Try mixtures of indigo and burnt sienna for a deep, rich brown.

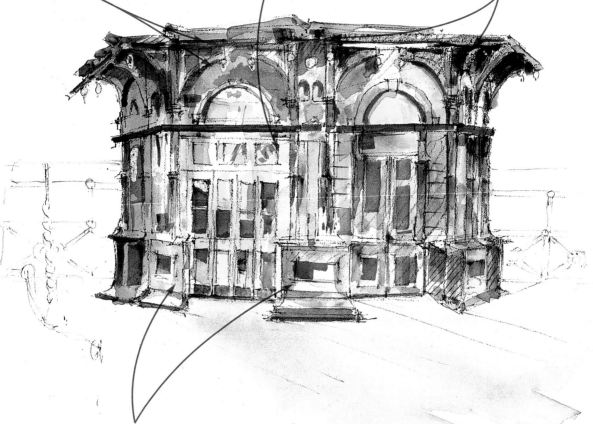

The ironwork, once a brilliant green, has faded over the years to produce a pale blue-green. You can use watered viridian for these areas.

STAGE 5
PUT IT IN CONTEXT

■ Now you can complete the sketch by adding the background and painting some additional foreground detail. Make sure all the previous colours have dried, and then paint in the sky with a mixture of indigo and ultramarine blue, grading to viridian for the area of sea at the bottom. Because you will have to take the wash carefully around the edge of the kiosk, you won't be able to lay it as freely and rapidly as you might on blank paper, and it may not go on evenly, but this is an advantage, as it will add to the atmosphere of the sketch and give a suggestion of clouds.

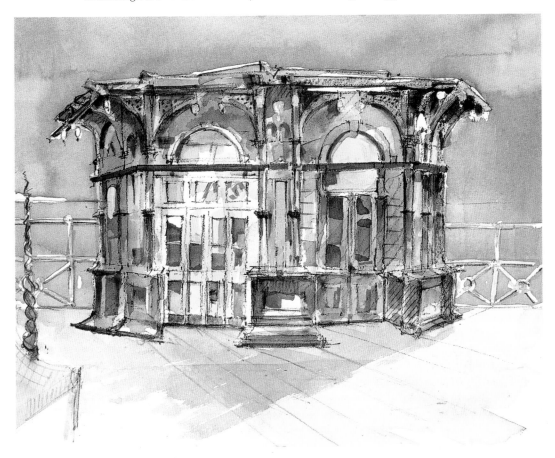

The soft merging of sky into sea and the blue-grey of the sky both suggest an overcast day, which is not strictly realistic, as the shadows suggest sunshine. But this piece of artistic licence gives the painting a strong feeling of atmosphere.

If you have used masking fluid, remove it by rubbing with a finger or eraser, but make sure the sky wash is dry first. If you have accidentally painted over any highlights, reclaim them with white gouache paint.

The foreground need not be over-detailed, but the shadow is important as it provides a balance for the building, so be careful with the shape. Sketch in the old seat very lightly. You do not want it to attract too much attention. Use raw sienna for this, to echo the lighter areas of the kiosk.

Strengthen the viridian here to make it stand out. The use of the same colour in a weaker version for the sea provides a link that unifies the sketch.

FOCUS ON BUILDINGS
Capturing reflections

Reflections of buildings in water can make a lovely subject, much exploited by artists. A still expanse of water acts exactly like a mirror, producing a reversed image of what is above, so the height of the reflection and the perspective will be the same as that of the building, as will the perspective, with both object and reflection sharing the same vanishing point or points. Thus, painting the reflection of a vertical structure such as a building presents no problems; but if an object is leaning towards you, it will be foreshortened, and the reflection will be longer than the object itself.

Mirror image
Slightly blur the surface of very still water, otherwise you will lose its horizontal surface.

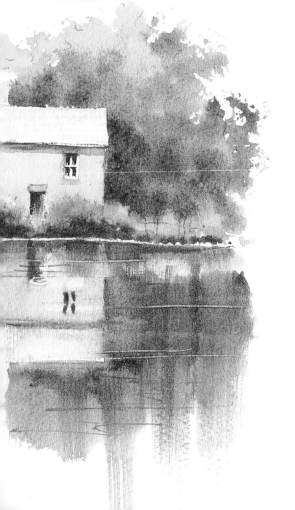

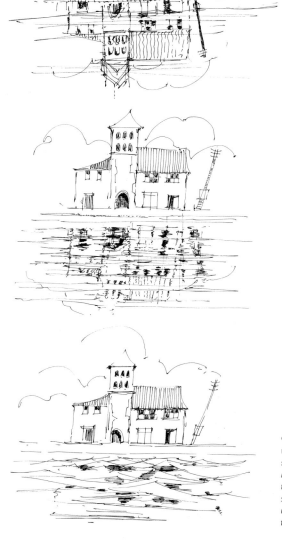

Calm, choppy and rough water surfaces *The more rough the surface of the water, the more scattered and unpredictable the reflection.*

The water surface

Problems arise when the surface of the water is disturbed; ripples create many small, reflective surfaces set on inclined or near-vertical planes instead of just one large horizontal plane. The ripples scatter the reflections sideways or downwards, so that you can no longer see the perspective effect, and you will have to observe very carefully to see where the little patches of reflection fall.

These broken reflections can make an attractive foreground, allowing you to contrast the fluid water with the solid building or buildings. But even when you are dealing with a reflection in a flat expanse of water, you need to find ways to express both the fluidity and the horizontality of the water surface. You may have to use a little artistic licence here, such as suggesting one or two ripples by making light horizontal lines across or below the reflection. You can also treat the reflection more lightly than the building; even if you can see all the details, you don't have to include them.

Reflections in windows *Observe how the sky is reflected in windows and bring this into your sketch to add colour and interest.*

Reflections in puddles *This sketch has a more interesting composition when the house is reflected in the puddles in the foreground.*

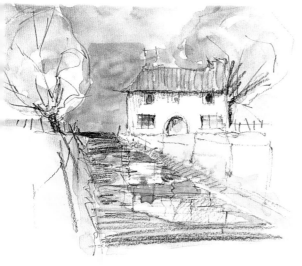

Other reflections

There are other types of reflection to look out for as well as the obvious ones – for example, the light bouncing off a wet road to lighten the walls of a building, or puddles reflecting either small areas of a building or the sky above. You may also see the sky reflected in windows or other shiny surfaces, which could be a bonus if you are working in colour.

EXERCISE 16

Reflections in a canal by Jim Woods

Venice is a paradise for the artist and has been for centuries. Tourists are drawn to the major attractions such as St Mark's Square and the marvellous view of San Giorgio and the Salute across the Grand Canal, but the quieter squares and lesser-known canals provide equally fascinating subjects for the artist and may even enable you to set up an easel without the danger of being trampled by tourists. The view chosen here is one such example.

> **Practice points**
> - **CONTROLLING THE SHADOWS**
> - **RESTRICTING THE COLOURS**
> - **USING LINE WITH WATERCOLOUR**

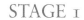

Check the angles carefully and make sure the verticals are truly vertical. You can measure from the edges of the paper if you have any doubts.

STAGE 1
START THE DRAWING

■ Use a viewfinder to work out the composition and establish where the boundaries are to be, then sketch in the rough outlines with a carbon pencil, working on watercolour paper. Carbon pencil makes a darker, heavier line than graphite pencil, but this does not matter, as part of the drawing is intended to show through the paint.

Draw in the main lines of the reflections. You never know when a wind might spring up to ruffle the water surface, so it is wise to establish these at the outset.

STAGE 2
ADD DETAIL
■ Continue to develop the drawing, adding the main architectural features such as windows, balconies, roof overhangs and chimneys. Check angles and proportion carefully as you go. A touch of pencil shading here and there helps to add depth to the scene.

Note that the line of buildings here turns a corner, so that the angle slopes down more sharply on the right.

Look for small decorative touches that will give an extra sparkle to the picture and enhance the 'sense of place'.

The arch provides foreground interest, breaking up the large expanse of shadowed wall.

The barge is to be left mainly as white paper, standing out from the surrounding dark reflection, so it is important to establish this shape in the early stages.

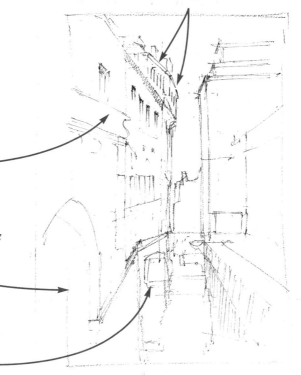

Let the sky wash dry and then lay another wash of raw sienna over the buildings, leaving the balcony, arch and area on the top left white for the time being.

The drawing shows through the pale wash, so this area will need little or no extra definition.

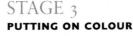

STAGE 3
PUTTING ON COLOUR
■ Add the final details, then begin to add colour. The scene provides a built-in colour scheme based on the contrast of blue and yellow, which are nearly complementary, so make the most of this and try to limit the range of colours to give unity to the picture.

Paint the sky with a wash of ultramarine blue, which is a warm blue and will contrast well with the yellows and browns of the buildings. Grade the wash so that it is darker at the top of the sky and the bottom of the water.

STAGE 4
PAINT THE SHADOWS

■ It is not always easy to know how to treat shadows, as they can easily become too dark and muddy. Remember that the colour of the surface will influence cast shadows, so try not to lose sight of this relationship. The artist has decided to paint the shadows in two stages, laying one colour over the other.

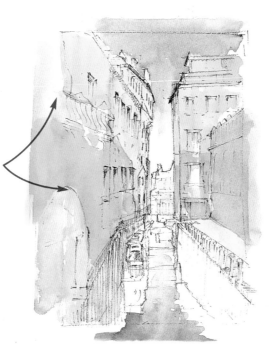

Notice that the colour changes according to whether it was laid on white paper or over the original yellow-brown. Mixing colours on the paper in this way often provides more exciting effects than pre-mixing in the palette.

The shadows reflected in the water are cooler in colour, as they are influenced by the sky colour, so use a mixture of sepia and ultramarine blue for these. Repeat this colour on the right-hand building to tie these two areas together.

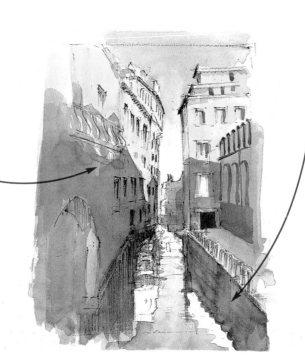

Lay a pinkish brown wash (alizarin brown madder or a mixture of colours) over the shadowed areas.

Build up the tonal contrast by darkening these areas, using the same mixtures as before. Take small brushstrokes of the dark colour out into the water to suggest the slightly rippled surface.

Make the colour quite strong here, but break up the reflections by using separate brushstrokes and leaving small patches of white paper showing.

Paint the shutters with viridian, then paint a shadow at the left side of the arch and add a little more drawing on the right side to define the shape. Use the carbon pencil again to draw more detail on the balcony.

Make a few light pen lines in places to give variety to the drawing, but don't overdo these and avoid making them too precise.

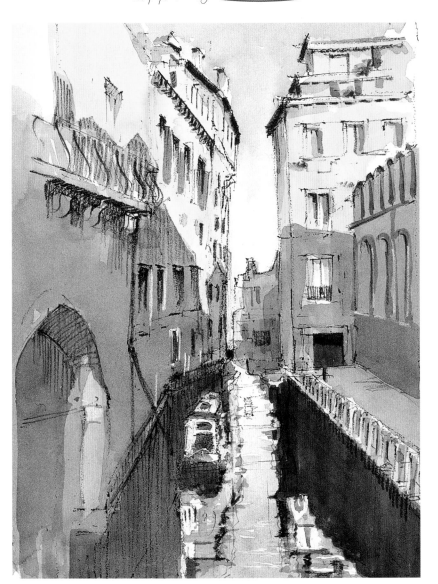

STAGE 5
FINAL TOUCHES
■ Although the reflections are the central theme of the painting, they must be left until all the other colours are in place, and the same applies to the final details. You may find it easier to paint the reflections with the board turned upside down, which is the method favoured by the artist. When these are complete, take a break and then decide what more needs to be done, such as extra drawing and strengthening tones and colours here and there.

Media Technique Directory

Dry media such as wooden and carbon pencils, charcoal, soft and hard pastels, carrés and coloured pencils are flexible tools for sketchers. Although the choice is seemingly endless, your art supplier will be able to advise you. Wherever possible, buy pencils and pastels singly, rather than in boxed sets.

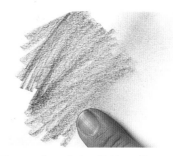

▲ Tone can be varied and lightened by blending different weight of pencil with a finger, torchon or soft eraser.

WOODEN PENCIL

▲ A wooden pencil is a graphite strip sealed into a wooden case. It can be used on a variety of different surfaces to produce a wide range of linear effects. Note the difference between the lines made with a hard B, a 2B and a soft 6B pencil (left to right).

▲ Lines can be hatched or cross-hatched with a wooden pencil to build up areas of varying tone and density.

▼ Create areas of tone using a soft pencil. The heavier the pressure, the darker the tone.

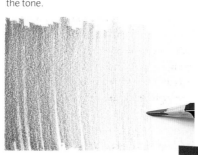

Cartridge paper and pads

Cartridge paper is available in a range of weights and comes in sheets, rolls, pads and sketchbooks. Its primary use is for drawing with dry media and ink, and it is not ideal for pastel, charcoal or watercolour.

CARBON PENCIL

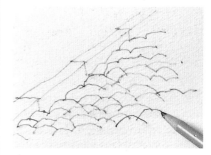

▲ A carbon pencil is compressed charcoal sealed into a wooden case. It is a soft pencil that gives a rich black line with very little pressure. Used on damp paper it gives an even denser, velvety black line.

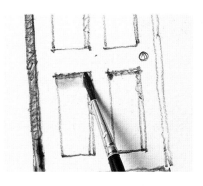

◀ A line made by a carbon pencil will spread and soften when washed over, making some wonderful grey shadows.

CHARCOAL

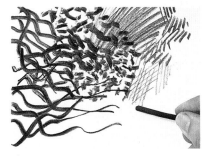

▲ Thin stick charcoal produces expressive, linear strokes. You can vary the thickness of the stroke by changing the angle of the charcoal stick on the page. Thick marks can be made by using the charcoal on its side.

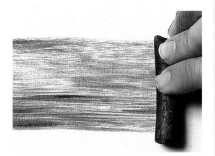

▲ You can cover a large mid-tone area by using a charcoal stick on its side, creating wonderful textures.

▼ Charcoal is easy to smudge, and lines can be softened with a finger or paper-blending stump.

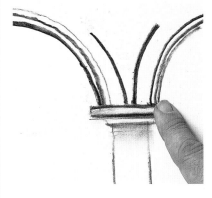

▼ Create highlights in an area of tone – or correct errors – by lifting out the charcoal with a putty eraser (knead the eraser into a point for small details). This can produce a variety of effects, from sharp lines to texture and highlights, and is perfect for lifting out light reflected on window panes.

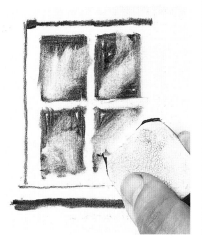

SOFT PASTEL

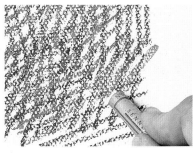

▲ Soft pastels are the most commonly used pastels and offer the largest choice of tints and tones. Crossing one set of hatched lines with another increases the density of colour and tone.

▲ Used on its side, pastel makes a broad area of solid colour. Be sure to protect your work, as soft pastels crumble easily and can be messy to use.

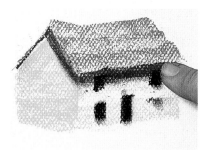

▲ Your finger is an ideal tool for blending and can be used to vary the tone density or even add soft shadow to a roof overhang.

HARD PASTEL

▲ Hard pastels are usually square, but can be sharpened to a point with a sharp craft knife. Use the end or sharp edge of the pastel to create lines, strokes, dashes and dots.

▲ Block in large areas by using a hard pastel on its side.

▲ Hard pastels come in a large range of wonderful colours, which can be combined or blended for added impact.

Pastel sheets and pads

Most pastel artists will use specially textured pastel papers that will hold several layers of dry pastel dust without becoming saturated. Pastel papers are available in a wide range of colours.

▲ To soften and blur edges such as a shadow behind a shutter, blend with a finger, brush, rag or torchon.

▶ Smudge the line with a finger or torchon to soften your sketch and blend colours. This has brought added texture to the roof of this small cottage.

PASTEL PENCIL

▼ Pastel pencils are made of a strip of hard pastel secured inside a wooden case. They are ideal for line work, especially when working detail into a sketch made with soft or hard pencils. Sharpen pastel pencils with a traditional pencil sharpener or craft knife.

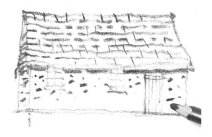

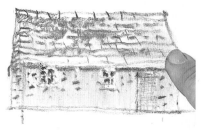

COLOURED PENCIL

▼ Coloured pencils can create fluid lines and textural marks of varying thicknesses.

▲ Angle the coloured pencil before blocking in colour to create a consistent tone.

▲ Lighter pressure will result in lighter colour or tone, whereas heavy pressure will give a darker or deeper colour or tone.

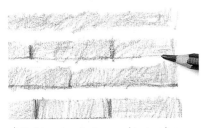

▲ Build up density, tone and texture by mixing and overlapping colour. From a distance, two colours that are closely worked will appear as a solid blend of the two colours.

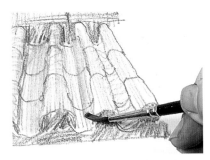

▲ Washing water over coloured pencil marks – wet-on-dry – will add more depth to your sketch.

CONTÉ STICKS/CARRÉ PENCILS

▲ Used on its edge, a conté stick will make a variety of different textural marks; however, a carré pencil will make a finer line.

Using fixative

Fixative leaves a matt layer of resin that coats and holds any loose pigment dust in place. It is usually used with charcoal and pastel sketches. Fixative is available in aerosol cans, and in bottles that use a pump action or need a diffuser, and should always be sprayed away from the face and clothing.

▲ Like a graphite pencil, a conté pencil can be used to hatch and shade, bringing texture to your work.

▲ Use a conté stick on its side to produce a block of solid colour.

OIL PASTELS

▲ Oil pastels can be opaque, semi-transparent or transparent. They can be used to make fine linear strokes and textural marks.

TECHNICAL PEN

▲ A technical pen delivers ink to the paper through a narrow metal tube, producing an unvarying line width that is unaffected by hand pressure. It is ideal for detailed linework such as adding texture to these bricks.

BALLPOINT PEN

▼ Although ballpoint pens produce lines of uniform width, the end result can look lively and spontaneous.

MARKER AND FELT-TIP PENS

▼ Marker and felt-tip pens can produce a variety of lines and marks. Here, a fine-tipped pen has been used to hatch, cross-hatch and make lines and marks.

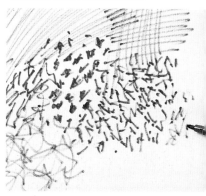

▼ Markers are either water- or solvent-based. You can make interesting effects by working into drawings with water.

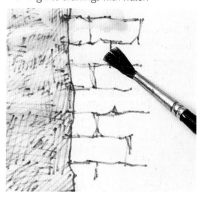

Acetate and tracing paper

Tracing paper is used to transfer drawings from one surface to another, while acetate is often used to make up grids (see page 10).

Watercolour paper

Watercolour paper is woven, acid-free and usually white. It comes in degrees of thickness and in three different textures: rough, cold-pressed (also known as NOT) and hot-pressed. Machine-made watercolour paper is the most inexpensive of watercolour papers, but may distort when wet. Mould-made papers are more durable, and less resistant to distortion. The best, but most expensive, type is handmade.

INK

▲ Vary the angle of the brush or the pressure on the paper to alter the thickness of the line.

▼ You can mix colours by laying one colour over another, usually working light to dark.

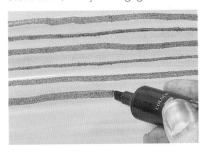

▲ Hatch or crosshatch lines with the dip pen to create texture, and light and dark tones.

▼ Use a wide-tipped marker pen to create blocks of colour.

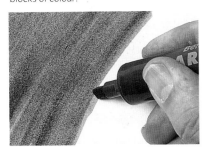

▶ To create tone with a brush, dilute the ink with water; the more water you add, the lighter the ink.

▼ A dip pen is flexible and results in expressive lines of varying widths, depending on the pressure you put on the nib. Used over a dry wash, this technique can allow for great detail.

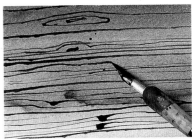

▲ If water-resistant ink is used, as here, tonal washes can be applied to linework. If the ink is water-soluble, essential marks may need to be redrawn when the wash is dry.

WATERCOLOUR

▲ Before you begin, make sure that you have mixed enough paint to complete the task. A flat wash needs to be applied at a slight 20-degree angle. Load a large wash brush with paint and, starting at the top, make a steady horizontal stroke across the paper. The next stroke will need to overlap the first slightly.

▼ A graded wash is a variation on the flat wash. However, each time you make a horizontal stroke, add more water to the mixture, making it slightly lighter (or add more paint to make it darker).

▼ Apply wet paint to an area that is already wet with paint. Depending on how wet the base layer is, the technique results in colours flowing and blending together.

▲ Brush masking fluid onto the paper on the areas you wish to preserve. Masking fluid can be applied with a brush, pen or finger.

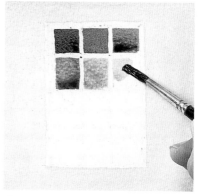

▲ Once the masking fluid is dry, it will repel liquid paint, protecting the area beneath.

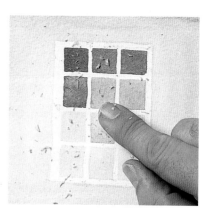

▲ Once the paint is dry, gently rub off the masking solution with a finger.

Watercolour pads

Watercolour pads can be bought in separate sheets or in pads or sketchbooks of varying sizes.

▼ To create texture, rub a clear wax candle over the areas to which you wish to add texture.

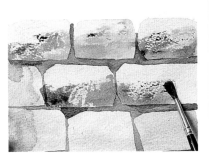

▲ Watercolour paint will resist settling in those areas that have wax on them.

▼ Sgraffito, or scratching out, can be made with any sharp implement. Here, the artist scratches out highlights with a craft knife.

Stretching paper

Most paper will swell and buckle if it is wet. When working with wet media such as watercolour, stretch the paper in advance to avoid ruining your work.

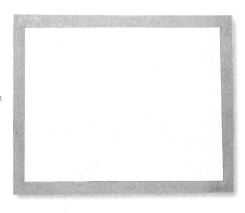

1 Place your paper on a large board.

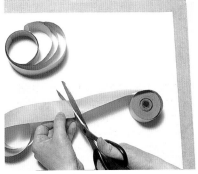

2 Measure and cut pieces of adhesive paper tape, to fit around the edge of the paper.

3 Dampen the sheet of paper in a tray of clean water.

4 Lay the paper on the board. Dampen the strips of paper tape and lay each strip along the edge of the paper, with one-third of the tape covering the paper and the rest covering the board.

5 Smooth the surface of the tape down with the sponge. Gently wipe the excess water from the paper and leave to dry until the paper is taut. When dry, remove the paper from the board by cutting away the tape with a craft knife.

Suppliers

Many of the materials used in this book can be purchased at good art supply stores. Alternatively, the suppliers listed below can direct you to the retailer nearest you.

NORTH AMERICA

Asel Art Supply
2701 Cedar Springs
Dallas, TX 75201
Toll Free 888-ASELART (for outside
 Dallas only)
Tel (214) 871-2425
Fax (214) 871-0007
www.aselart.com

Cheap Joe's Art Stuff
374 Industrial Park Drive
Boone, NC 28607
Toll Free 800-227-2788
Fax 800-257-0874
www.cjas.com

Daler-Rowney USA
4 Corporate Drive
Cranbury, NJ 08512-9584
Tel (609) 655-5252
Fax (609) 655-5852
www.daler-rowney.com

Daniel Smith
P.O. Box 84268
Seattle, WA 98124-5568
Toll Free 800-238-4065
www.danielsmith.com

Dick Blick Art Materials
P.O. Box 1267
Galesburg, IL 61402-1267
Toll Free 800-828-4548
Fax 800-621-8293
www.dickblick.com

Flax Art & Design
240 Valley Drive
Brisbane, CA 94005-1206
Toll Free 800-343-3529
Fax 800-352-9123
www.flaxart.com

Grumbacher Inc.
2711 Washington Blvd.
Bellwood, IL 60104
Toll Free 800-323-0749
Fax (708) 649-3463
www.sanfordcorp.com/grumbacher

Hobby Lobby
More than 90 retail locations throughout the US. Check the yellow pages or the website for the location nearest you.
www.hobbylobby.com

New York Central Art Supply
62 Third Avenue
New York, NY 10003
Toll Free 800-950-6111
Fax (212) 475-2513
www.nycentralart.com

Pentel of America, Ltd.
2805 Torrance Street
Torrance, CA 90509
Toll Free 800-231-7856
Tel (310) 320-3831
Fax (310) 533-0697
www.pentel.com

Winsor & Newton Inc.
PO Box 1396
Piscataway, NY 08855
Toll Free 800-445-4278
Fax (732) 562-0940
www.winsornewton.com

UNITED KINGDOM

Berol Ltd.
Oldmeadow Road
King's Lynn
Norfolk PE30 4JR
Tel 01553 761221
Fax 01553 766534
www.berol.com

Daler-Rowney
P.O. Box 10
Bracknell, Berks R612 8ST
Tel 01344 424621
Fax 01344 860746
www.daler-rowney.com

Pentel Ltd.
Hunts Rise
South Marston Park
Swindon, Wilts SN3 4TW
Tel 01793 823333
Fax 01793 820011
www.pentel.co.uk

The John Jones Art Centre Ltd.
The Art Materials Shop
4 Morris Place
Stroud Green Road
London N4 3JG
Tel 020 7281 5439
Fax 020 7281 5956
www.johnjones.co.uk

Winsor & Newton
Whitefriars Avenue
Wealdstone, Harrow
Middx HA3 5RH
Tel 020 8427 4343
Fax 020 8863 7177
www.winsornewton.com

Index

Credits

Quarto would like to thank and acknowledge the following for permission to reproduce the pictures that appear in this book.

Key: b=bottom, t=top, c=centre, l=left, r=right

Bob Brandt 54l; **Geoff Kersey** 96l; **Nicolette Linton** 82t, 98t; **Valerie Warren** 33tr, 67b; **Jim Woods** 2–3t, 10–11c, 19b, 22b, 23t, 33tl, 54–55tc, 55b, 66b, 67tr, 76–77, 96r, 97

Ian Sidaway for demonstrating the media techniques shown on pages 102–109.